POSTCARD HISTORY SERIES

Along the Allegheny River

THE NORTHERN WATERSHED

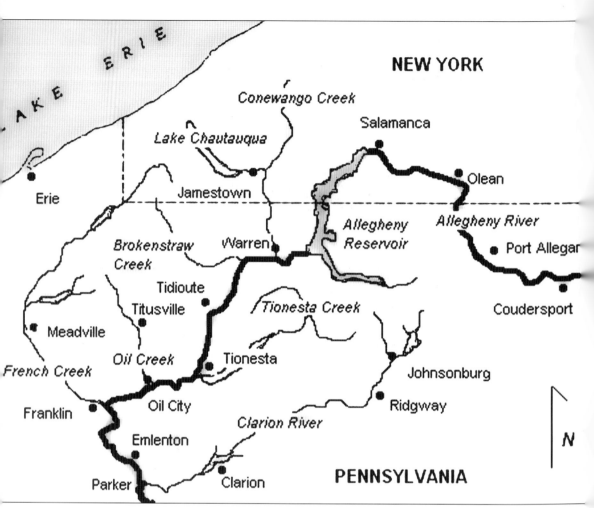

Seen here is a map of the Northern Allegheny Watershed as considered in this book. The Northern Watershed originates in Potter County, Pennsylvania, extends into southwestern New York, and ends at the Clarion River near Parker, Pennsylvania.

On the front cover: Seen here is the Devil's Elbow of the Allegheny River in the 1930s, north of Warren, Pennsylvania, looking toward the village of Kinzua, as seen from old Route 59. (Author's collection.)

On the back cover: The Allegheny River at Warren, Pennsylvania, downstream of the current Pennsylvania Avenue Bridge is seen here around 1905. (Author's collection.)

POSTCARD HISTORY SERIES

Along the Allegheny River

THE NORTHERN WATERSHED

Charles E. Williams

ARCADIA

Published by Arcadia Publishing
Charleston SC, Chicago IL, Portsmouth NH, San Francisco CA

Printed in the United States of America

Library of Congress Catalog Card Number: 2005925431

For all general information contact Arcadia Publishing at:
Telephone 843-853-2070
Fax 843-853-0044
E-mail sales@arcadiapublishing.com
For customer service and orders:
Toll-Free 1-888-313-2665

Visit us on the Internet at http://www.arcadiapublishing.com

CONTENTS

Acknowledgments 6

Introduction 7

1. The Upper Allegheny Valley 9

2. The Conewango Valley 33

3. The Brokenstraw Valley 41

4. The Oil Creek Valley 47

5. The French Creek Valley 55

6. The Tionesta Creek Valley 67

7. The Clarion River Valley 73

8. The Middle Allegheny River Valley 91

References 127

ACKNOWLEDGMENTS

A writer's task is often a lonely one. I have been lucky—many people and institutions have provided the support, inspiration, and encouragement that have made this project a reality. My wife, Kim, and our daughters, Tara and Kelsey, have been very supportive of my Allegheny River addiction, experiencing its landscapes with me on foot, by bike, and by kayak. They have also been very tolerant of being dragged through antique stores and flea markets on the hunt for a good postcard. I could not have done this book without them.

I also thank the many Clarion University students who have helped me in my studies of the Northern Watershed's many ecological and historical treasures, from salamanders to old-growth forests. None of my field work could have been possible without the financial and logistic support of the Allegheny National Forest over the years, which I greatly appreciate. I also thank Clarion University of Pennsylvania for library support and the opportunity to study, and teach about, the Allegheny River Basin, our unique backyard.

My friend and colleague Billy Moriarity—retired soil scientist, Allegheny National Forest—deserves special thanks. Billy helped launch my studies on the Allegheny's Northern Watershed, and he has been a constant supporter of my work. My students and I have learned much from his "Billyisms" over the years. I am indebted to Billy, as he taught me how to "read" landscapes and encouraged my interest in historical studies that integrate the natural and human environments. I dedicate this book to him.

Finally, I extend my thanks to the folks at Arcadia Publishing, especially senior editor Erin Vosgien, for their patience, encouragement, and support.

INTRODUCTION

Five years ago, I embarked on a project that would ultimately grow into this book. I was granted a sabbatical from the university at which I work to explore the ecological history of the Allegheny River Valley. My goal was to understand how human land use had changed the landscapes of the river valley, focusing on the unique floodplain forests and islands on a stretch of the river between Warren and Tionesta, below the Kinzua Dam. During the scope of the project, I hiked the Northern Allegheny's banks, I kayaked its waters, I biked its railroad beds, and I drove its winding back roads. I conducted field studies of its forests and waters. I poured over maps, historical photographs, postcards, old surveys, and many a dusty book. In the end, I completed the project, wrote my technical papers, and gave my scientific talks. But my time on the Allegheny had changed me. The river and its landscapes had become more than an object of study: they had become a part of me—a passion.

About 320 miles long, the Allegheny River of western Pennsylvania and southwestern New York flows through a region rich in natural resources and human history. The Allegheny rises in Potter County, Pennsylvania, flowing northwest through New York's southern tier—Cattaraugus and Chautauqua counties—to reenter Pennsylvania in northern Warren County. From the state line, the Allegheny flows south over 200 miles to meet the Monongahela River at Pittsburgh to form the Ohio River, a major tributary of the Mississippi. That water welling up from the northern Pennsylvania springs, giving birth to the Allegheny and joined by the flows of many tributaries, ultimately reaches New Orleans and the Gulf of Mexico.

The Allegheny River Basin, with its Northern and Southern Watersheds, is a study in contrasts. The Northern Watershed, the scope of this book, is a region of scenic, winding creeks and rivers, abundant trout streams, deep forests, and small villages. The wealth of white pine in the Northern Watershed fueled a colorful lumber rafting era that persisted from the early 1800s to 1920. Railroad logging was born on the Northern Watershed in the 1880s, and the industrial-strength harvest that it inflicted can still be seen in today's forests. Bark of its abundant hemlock supported some of the largest tanneries in the world through the 1930s. The discovery of oil in 1859 on Oil Creek near Titusville, Pennsylvania,—the "valley that changed the world"—shifted the boom from lumber to petroleum. The quest for oil continues in the region today. The Southern Watershed and its rich mineral resources, iron and coal, helped forge the Industrial Revolution, and its marks—coal mines, mills, warehouses, and factory towns—are scattered across today's landscapes. Andrew Carnegie, John D. Rockefeller, J. P. Morgan, and Henry Clay Frick built their fortunes and industrial empires in large part from natural resources of the Allegheny Basin—oil, iron, steel, coal, and coke. Once part of the fleeting North American empire sought

by the French and English in the 18th century and revered as homeland and hunting grounds by the Seneca, Delaware, and Shawnee Indians, the Allegheny River Basin is a landscape shaped by millennia of natural processes and centuries of human endeavor and desire. Few landscapes in the eastern United States tell a more enthralling story of the clashing of cultures, the boom and bust of industry, and the place of humans in the landscape than does the Allegheny Basin.

My interest in vintage postcards began when I found a haunting image of a young girl standing beside the Allegheny River near Warren, dated 1905. Written on the bottom of the card was a simple yet profound message: "Beauty." It made me think of past times on the river, its people, their lifestyles, and how the river was the fabric of their everyday lives. I began to collect more postcards of the Allegheny and its major tributaries—the Clarion River, French Creek, and Tionesta Creek. I learned more about the region's geography and history. Towns and cities—Smethport, Olean, Tidioute—became more than dots on a map or places that I have driven through heading somewhere else. They became focal points of a larger story. I became firmly hooked on postcards and their historical value. The end result is this book, which I hope will interest and inform a larger audience about the history of this fascinating and beautiful river valley. I should stress that *Along the Allegheny River: The Northern Watershed* is neither a comprehensive history nor a complete geography of the region. Instead, it is a series of focused vignettes of the Northern Watershed as seen through the postcards of a bygone era.

As an ecologist, I have organized the information in this book in a different manner than a historian or a geographer may. I have broken up the Northern Watershed of the Allegheny into its basic constituent parts—watersheds. A watershed is a drainage basin delineated by the landforms that surround it, forming a self-contained unit linked to the larger landscape by its fluxes and flows of water. Watersheds are the basic building blocks of landscapes. Moreover, watersheds reflect human history and, in many instances, shape it. Take, for example, the Oil Creek Valley. Endowed with rich petroleum reserves, the Oil Creek Valley was developed in a different manner and intensity than the Tionesta Creek Valley, which had some oil reserves but was richer in timber. I have followed the watershed classification of the Allegheny Watershed Atlas in organizing the eight chapters of this book. Not all geographic locales, however, fit nicely in this scheme. Towns like Warren, Franklin, and Tionesta occur at the confluence of a major creek—Conewango, French, and Tionesta creeks, respectively—and the Allegheny River. In these instances, the towns are placed in one of the two watersheds focused on the main-stem of the Allegheny.

Finally, I must comment about the spelling of the river's name and how it varies geographically. Generally in Pennsylvania the river and its associated place names are spelled *Allegheny*. In New York and a few Pennsylvania locales (e.g., Port Allegany) the spelling is *Allegany*. I follow this convention for place names in Pennsylvania and New York but only refer to the river in the text as Allegheny.

One

THE UPPER
ALLEGHENY VALLEY

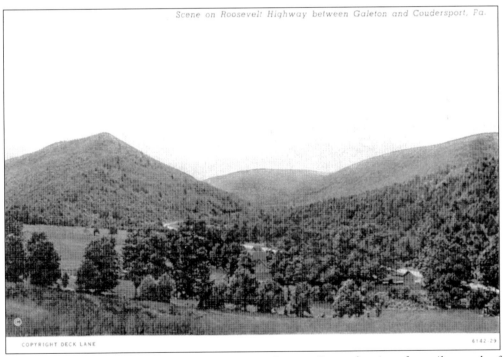

Scene on Roosevelt Highway between Galeton and Coudersport, Pa.

COPYRIGHT DECK LANE

The Allegheny River rises in northeastern Potter County, Pennsylvania, a few miles north of U.S. Route 6 on a flat plateau geologists call the "Triple Divide." On this unique site, three major drainages have their beginnings: the Genesee River flowing north to Lake Ontario; the West Branch of the Susquehanna River, via Pine Creek, flowing southeast to the Chesapeake Bay; and the Allegheny River flowing southwest through the Ohio and Mississippi valleys to the Gulf of Mexico.

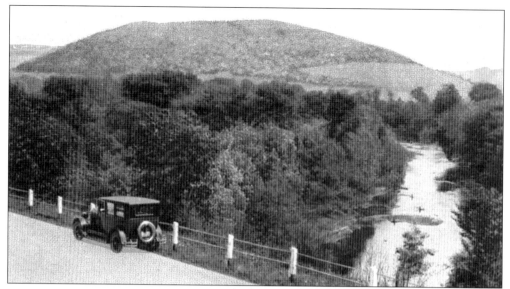

Route 6, the Roosevelt Highway, named after Pres. Theodore Roosevelt, traverses 11 counties and 400 miles of Pennsylvania's northern tier. Route 6 was largely built by incorporating other existing highways, ultimately forming the first transcontinental highway in the United States. The first segment of Route 6, from Provincetown, Massachusetts, to Brewster, New York, was designated in 1925. Within a year, Route 6 was extended to Erie, Pennsylvania, largely by incorporating the Roosevelt Highway.

The Roosevelt Highway was, and still is, an important east–west route through the Allegheny's northern watershed. Tourists, lured by scenic beauty, clean air, and quality hunting and fishing, funnel through the region on the Roosevelt Highway, heading to camps, cottages, and accommodations in the larger towns. Clusters of cottages, like the rustic cottages pictured here, sprang up along the Roosevelt Highway in the 1930s to 1940s in response to the growth of tourism.

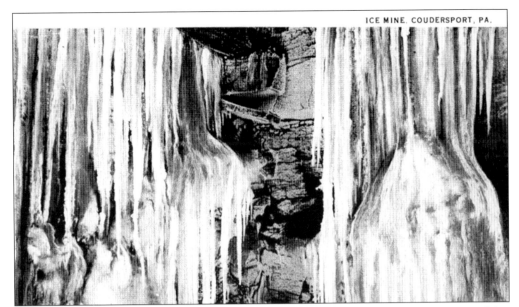

The Ice Mine, four miles east of Coudersport, was discovered in 1894 by a prospector searching for silver. Ice was never commercially "mined" from the Ice Mine as the name implies. Ice begins to form in the mine—a pit or shaft 10 feet long, 8 feet wide, and 40 feet deep—during spring, producing icicles that are 3 feet thick and 25 feet long by the summer. By the 1930s, the Ice Mine was an important tourist stop, with thousands of visitors annually.

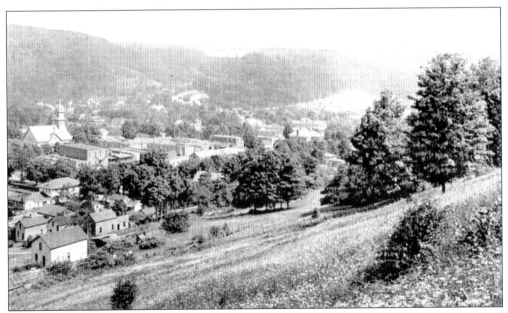

Potter County, named after Revolutionary War general James Potter, was created in 1804 from part of Lycoming County. Coudersport, the seat of Potter County, was founded in 1808. Historian Sherman Day found Coudersport a "small but thriving town" in 1843 with ". . . a stone courthouse and jail, an academy, three stores, two taverns, a carding machine, mills, and dwellings." The county courthouse, built in 1835 and renovated in 1888, is the large building with the clock tower in the left center view of this postcard.

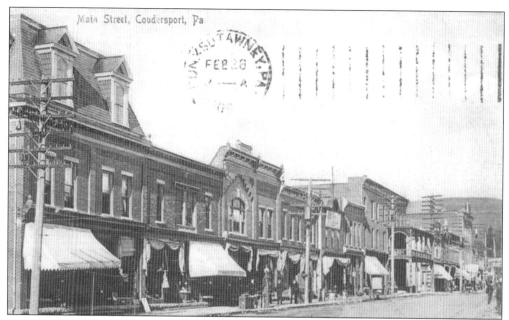

This postcard, postmarked 1908, shows a view of the Main Street business district of Coudersport. A 1915 commonwealth survey notes that Coudersport "... is a manufacturing town, its principal industries comprising the tannery of the Elk Tanning Company, employing about 300 men, a small condensed milk factory and several small plants for the manufacture of baskets, barrels, and clothespins."

This is a view of the Allegheny River near Port Allegany, McKean County—the "Canoe Place." The Allegheny Valley was an important transportation corridor for Native Americans. In the vicinity of Port Allegany, at least three Native American trails converged: the Sinnemahoning Path from Loch Haven; the Big Portage Path from Emporium; and the Ichsua Path from Port Allegany to Olean, New York. Canoe Place refers to a site where new canoes, probably from local white pine, were made to continue a voyage.

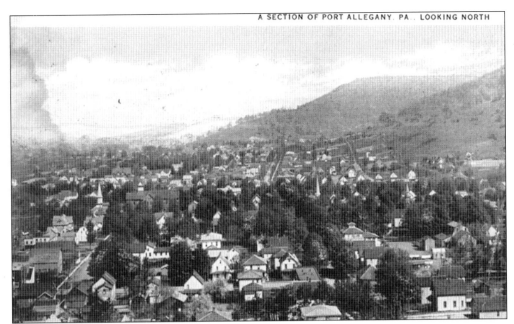

This birds-eye view is of Port Allegany from a sky-tint postcard postmarked 1929. By 1915, Port Allegany was an industrial town with three glass factories employing nearly 500 workers; a tannery of the Elk Tanning Company with 120 workers processing 500 skins daily; and a tan bark extract factory of the American Extract Company with about 20 workers. As early as 1883, Port Allegany's tannery was thought to be one of the largest in the United States.

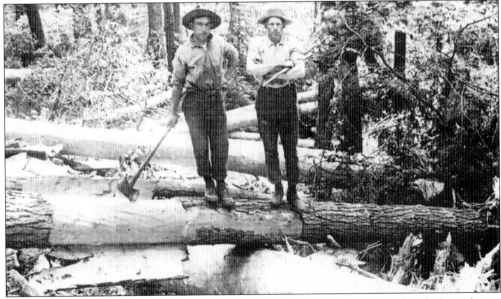

A vital ingredient for tanning leather was tan bark, harvested from eastern hemlock. As late as the 1880s, vast forests of hemlock remained on the Allegheny's Northern Watershed. Teams of men, like these two gentleman pictured in this postcard from the Pennsylvania Lumber Museum, would enter the forests in spring when hemlock bark is loose and easily peeled from the trees. The tanneries of northern Pennsylvania were insatiable, consuming an estimated 40,000 cords of bark and 4,000 acres of forest yearly by the late 1880s.

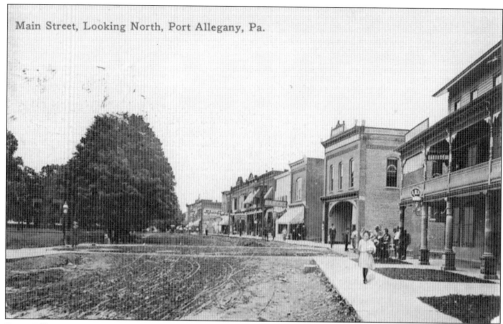

Main Street, Looking North, Port Allegany, Pa.

Port Allegany grew up around its town square, flanked by the Main Street business section. The top postcard, postmarked 1913, shows Main Street as a broad, rutted dirt track with wood-planked sidewalks fronting the businesses. The lower postcard, a litho-chrome produced in Leipzig, Germany, and published by J. Herbert Williams, shows the town square with its central gazebo and system of wood-plank sidewalks. Note the water faucet in the foreground.

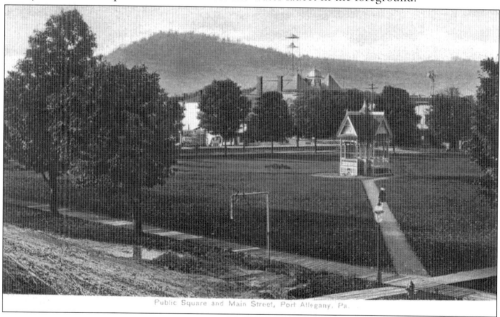

Public Square and Main Street, Port Allegany, Pa.

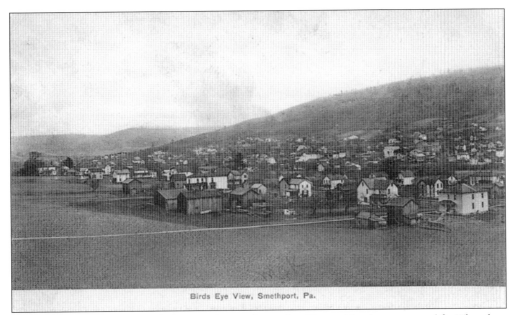

Birds Eye View, Smethport, Pa.

Smethport, the county seat of McKean County located on Potato Creek, was named for Theodore de Smeth, a Dutch agent for the Ceres Land Company, an entity that owned 300,000 acres in McKean and Potter counties. In the early 1900s, Smethport had a population of 2,000 and the town was a center of the glass industry hosting factories of the Birney-Bond Glass Company, the Smethport Cut Glass Company, and the Smethport Glass Company.

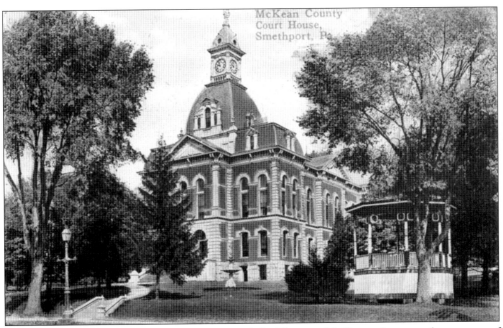

McKean County, formed in 1804, was named for Thomas McKean, the second governor of Pennsylvania and a signer of the Declaration of Independence. The top divided back postcard, postmarked 1913, shows the original McKean County courthouse designed by architect M. E. Beebe, built in Smethport in 1881.

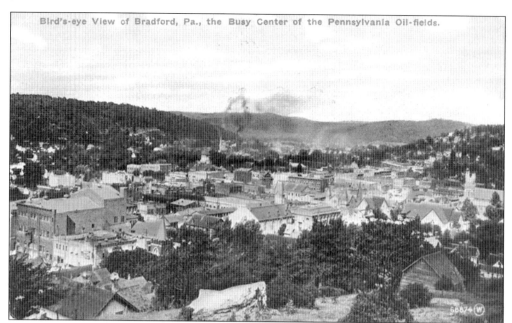

Bradford, Pennsylvania, located on Tunungwant Creek, was first settled in 1837 by Levitt Little, an agent of the United States Land Company. It was incorporated as a borough in 1872, with a population of about 600. Oil exploration near Bradford began in 1871. In 1875, the productive Crocker well was drilled and boom times ruled. Oil historian J. J. McLaurin noted that by 1876, Bradford had "Ten churches, schools, five banks, stores, hotels, three newspapers, street-cars, miles of residences, and fifteen-thousand of the liveliest people on earth . . ."

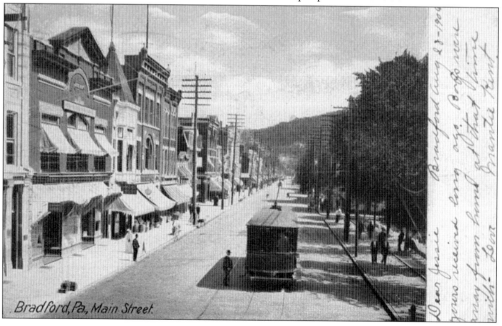

Bradford, Pa., Main Street.

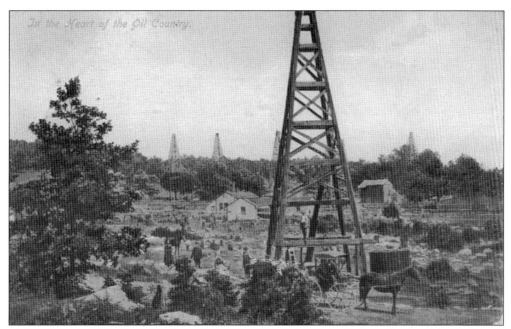

Eventually, the Bradford oil field would encompass 84,000 acres, including parts of Pennsylvania's McKean County and New York's Allegany and Cattaraugus counties. J. J. McLaurin quipped that after the discovery of the Crocker well, "Rigs multiplied like rabbits in Australia." And for good reason: of the 2,000 wells drilled from 1877 to 1878, only four percent were unproductive. The Bradford field was so prolific that by 1881 it produced over 90 percent of the nation's petroleum.

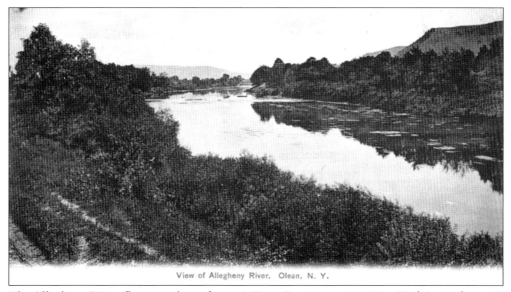

View of Allegheny River. Olean, N. Y.

The Allegheny River flows northeast from McKean County to enter New York in southeastern Cattaraugus County to become the Allegany River. The forests along this stretch of the Allegheny were impressive, especially their white pine, as described by historians J. W. Barber and H. Howe: ". . . along the Allegany river, there are broad belts of white pine . . . Some of the trees have measured 230 feet in height, and five of them have been known to furnish a hundred lumber-man's logs."

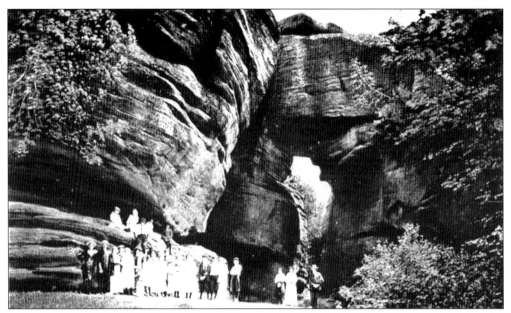

Rock City Park, near Olean, New York, is considered the world's largest deposit of quartz conglomerate rock or "puddingstone." Boulder "rock-houses," 30 to 40 feet high, are separated by fissures that resemble streets, hence the name "rock city." Rock City Park is a private attraction that opened to the public in 1890. Served by trolley, the park boasted the Bon Air Hotel and a dance pavilion where John Philip Sousa once performed.

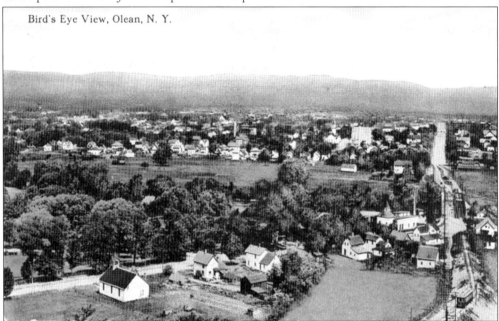

Bird's Eye View, Olean, N. Y.

In 1803, Maj. Adam Hoops, a Revolutionary War veteran, contracted with the Holland Land Company for 20,000 acres at the junction of the Allegheny River and Ischua (now Olean) Creek. Inspired by the Seneca Oil Spring near Cuba, New York, Hoops named the land at the confluence of the Allegheny River and Ischua Creek Olean Point for the Latin *oleum*, meaning oil. This birds-eye postcard shows a view of Olean in the early 1900s.

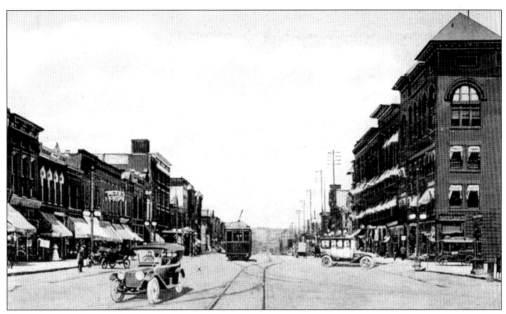

With the development of the Bradford oil field in Pennsylvania, Olean became a prosperous oil storage and refining area, reflected in the thriving town center depicted above. A pipeline linked a pump station in the Tunungwant Valley to storage tanks in Olean's Academy Hill in 1875. By the 1880s, Olean became the world's largest storage area for oil, with over 300 tanks. In 1881, J. D. Rockefeller's Standard Oil built a 315-mile pipeline from Olean to Bayonne, New Jersey. The pipeline operated until 1927.

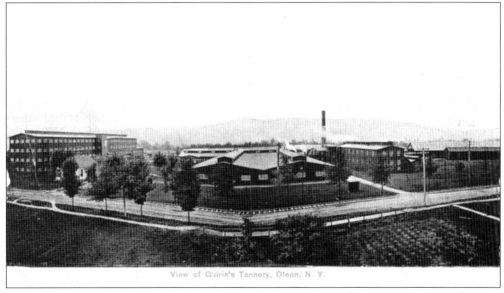

View of Quirin's Tannery, Olean, N. Y.

By 1915, five tanneries were in operation in Olean, including the Quirin Tannery depicted in this postcard, which is postmarked 1912. The long, shed-like structure in the right-center foreground of this view is a stack of hemlock bark. The tanning of each hide required 12 times its weight in bark, so tanneries needed to be close to bark sources. The message on this postcard reads ". . . worked this holiday. We go to Black Creek tomorrow from there I don't quite no where." Perhaps Black Creek, near Olean, was a source of tan bark.

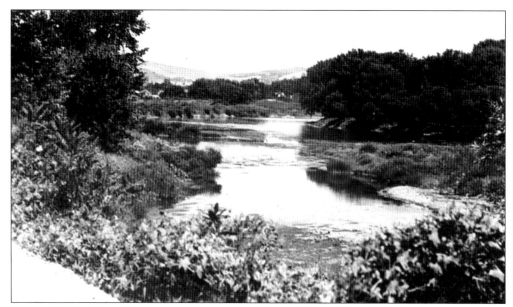

The Allegheny River flows between levees or dykes near Olean as shown in this postcard view from the 1950s. In 1942, a flood caused $3.7 million of damage to Olean, prompting the Army Corps of Engineers to improve the levee system. In all, six miles of existing levees were improved, one and a half miles of new levees were constructed, and a half-mile concrete flood wall was added.

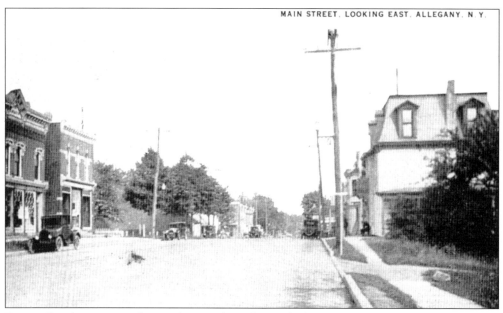

Four miles downstream from Olean is the village of Allegany. Near here in 1836, Nicolas Devereux bought a tract of land from the Holland Land Company on which he planned to build "Allegany City," a grandiose commercial and cultural hub for the region. The city was never built. The message on the blue-sky postcard below of Main Street Allegany, postmarked 1933, reads, "We get our meals from the convent," probably in reference to St. Elizabeth's Academy, a Franciscan girl's school founded in 1859.

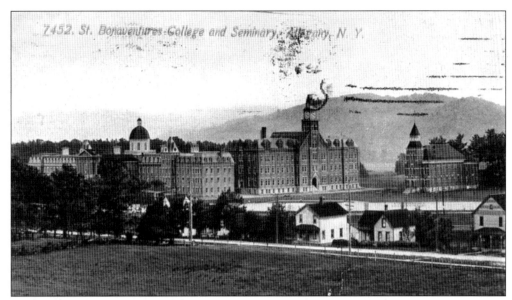

7452. St. Bonaventures College and Seminary, Allegany, N. Y.

One of Nicolas Devereux's schemes that did materialize was the founding of a Franciscan college on his land. Devereux journeyed to Rome and asked the Vatican to send Franciscan missionaries to western New York, offering $5,000 and 200 acres of land. The pope sent Devereux four volunteers in 1855, and by 1859, St. Bonaventure College opened its doors to 15 students. St. Bonaventure was incorporated as a college in 1875, and in 1950, it became the only Franciscan institution to achieve university status.

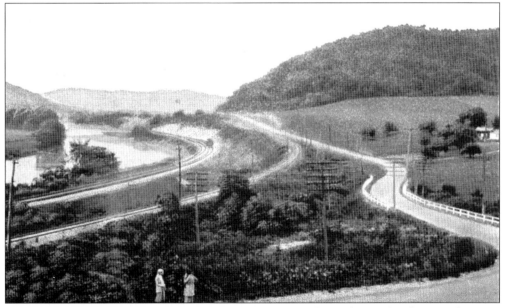

The Allegheny Valley was an important transportation corridor, as depicted in this scene between Olean and Salamanca, New York. The state highway referred to in the postcard's caption is probably the current New York Route 417. The dual sets of tracks include a railway—probably the tracks closest to the Allegheny River —and a trolley line. The trolley system in the region was impressive, connecting Bradford and Shinglehouse, Pennsylvania, with Olean, Salamanca, and other New York towns.

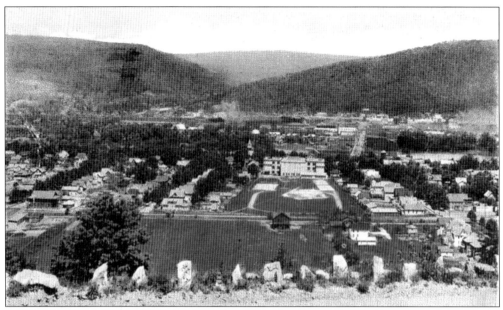

Salamanca is the northern gateway to Allegany State Park, and viewing the town from the park's overlook has been a tourist ritual since the park was established in 1921. In this view of Salamanca, postmarked 1929, the sender of the card writes, "We are having a wonderful time here. It really is a beautiful spot. We caught this view with our Kodak but don't know yet if it's any good."

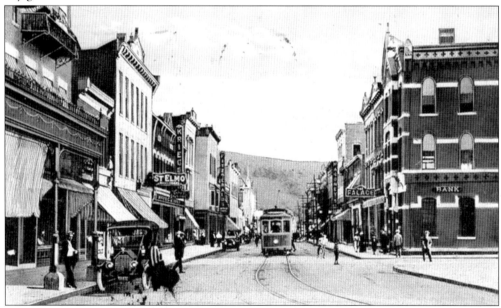

Salamanca was an important crossroad where rail lines from Pittsburgh, Erie, Buffalo, Rochester, and Cleveland met. The Erie Railroad reached the area in 1851, followed by the Atlantic and Great Western Railroad in 1872. The lines met at the small settlement of Bucktooth, which was renamed Salamanca in honor of Don Jose Salamanca y Mayol, a major railroad stockholder and capitalist from Spain. Salamanca is the only U.S. city to occur completely in an American Indian reservation, the Seneca's Allegany Reservation.

Northwest of Salamanca, on Little Valley Creek, is the village of Little Valley, the seat of Cattaraugus County. The county courthouse shown in this postcard, postmarked 1909, was built in 1867. Salamanca made an unsuccessful bid for the county seat in 1892. Cattaraugus is a Native American name that means "foul-smelling bank," probably in reference to the natural gas that exudes from the ground in several places in the county, especially along Cattaraugus Creek and Lake Erie.

The Allegany Reservation of the Seneca Indian Nation was a strip of land 40 miles long and one mile wide centered on the Allegheny River east of Salamanca, extending near the Pennsylvania border. The Allegany Reservation was one of 11 tracts reserved for the Seneca by the Treaty of Big Tree in 1797. This postcard, postmarked 1909, shows a "Typical Indian Dwelling – Salamanca, N.Y."

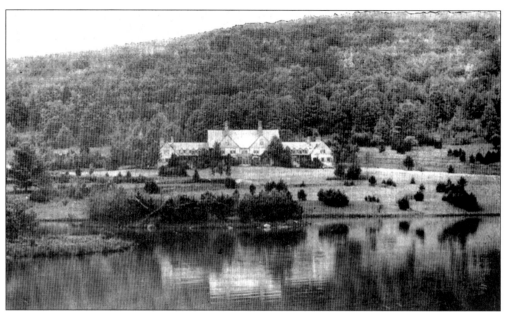

The 65,000-acre Allegany State Park, surrounded by the Seneca's Allegany Reservation, was established in 1921. Lands comprising and surrounding the park, originally 100,000 acres, were deeded to the state by the Holland Land Company in 1814 as part of the "Donation Lands" used as the company's contribution to building the Erie Canal. This view shows the park's Tudor-style administration building on Red House Lake, a recreation and administrative center.

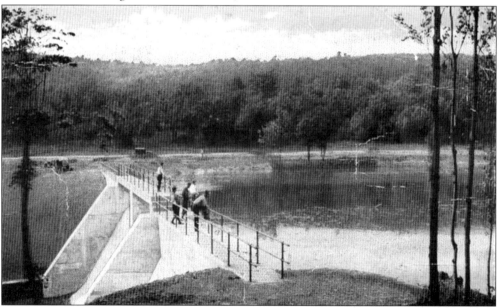

This view from a linen postcard postmarked 1940 shows the "Lake and Spillway, Allegany State Park." The dam depicted here forms Quaker Lake. The spillway marks the location of where the former Allegany and Kinzua Railroad crossed over Quaker Run to connect with other railways connecting Bradford and Corydon, Pennsylvania. The first tract acquired for Allegany State Park, 7,000 acres, was in the Quaker Run watershed near the former logging settlement of Frecks, named after H. C. Frecks, who built a band saw mill here in the 1880s.

The Allegany School of Natural History offered classes in Allegany State Park for two months in the summer. A vision of Chauncey J. Hamlin, a lawyer turned conservationist and president of the Buffalo Society of Natural Sciences, the school was intended "to supplement ordinary school work and give practical field instruction to teachers and leaders of young people's organizations in appreciation of outdoor life." The message on this card, postmarked 1935, reads ". . . Enjoying two weeks at Natural Science Camp . . . Dad and Hildegard S."

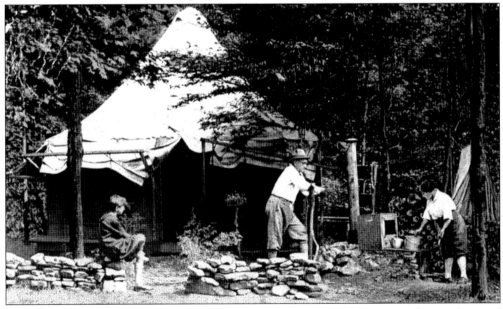

Parks are established for multiple uses, including conservation, education, and recreation, and Allegany State Park was no exception. Recreation, especially camping, was an important early use of the park, as shown in this card postmarked 1931. A vegetation survey of the park, published in 1937, recommended that campgrounds not be placed in forested areas because "humidity and air circulation is so poor," resulting in uncomfortable dampness and "danger from falling trees and branches."

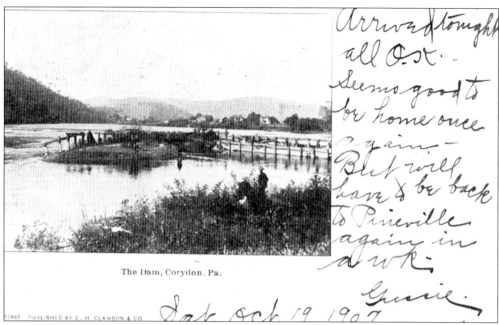

The Dam, Corydon. Pa.

Arrive tonight all O.K. Seems good to be home once again — But will have to be back to Pineville again in a wk. Gussie. Sat Oct 19 1907

12645. PUBLISHED BY C. H. CLAWSON & CO.

The Allegheny River reenters Pennsylvania in northeastern Warren County near the former town of Corydon, now flooded by the Allegheny Reservoir. This undivided back card, postmarked 1907, shows the remains of the old wooden dam across the Allegheny at Corydon, with a view of the town in the background. The slack water pool created by the dam was popular among anglers who often stayed at the Corydon House, a hotel built in the mid-1800s and closed in 1925.

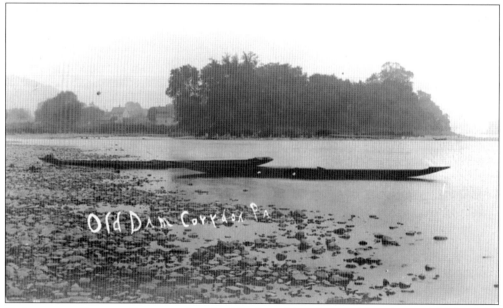

Old Dam Corydon Pa.

Various types of watercraft were used on the Allegheny River for travel, hunting, and fishing. This image shows two long, narrow wooden johnboats, popular craft on the Allegheny as they were maneuverable in shallow water. Johnboats were usually pushed with a long pole by a boater who stood in the middle of the boat. Johnboats were sometimes outfitted for night-fishing by equipping the bow and stern with burning knots of pitch pine providing light for spear-fishing.

The Cornplanter Tract of the Seneca Indians was located just south of Corydon on the west bank of the Allegheny River at the confluence of Cornplanter Run. The tract was named for Cornplanter, the distinguished Seneca chief. This postcard reproduces a portrait of Cornplanter that was painted from life in 1796 by the artist F. Bartoli. The portrait is thought to be the first truly American oil painting of a Native American.

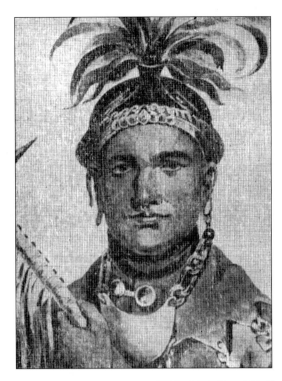

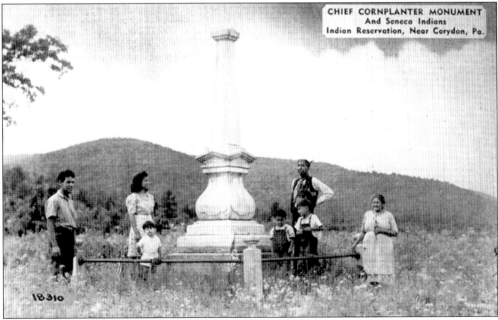

Cornplanter led the Seneca against the United States during the Revolutionary War but became an ally of the young republic in later years. In reward for his services, Pennsylvania granted Cornplanter and his heirs land along the Allegheny River in Venango and Warren counties, most of the latter lands to become the Cornplanter Tract or grant. In 1866, thirty years after his death, Pennsylvania erected this monument to Cornplanter, the first monument in the United States to honor a Native American.

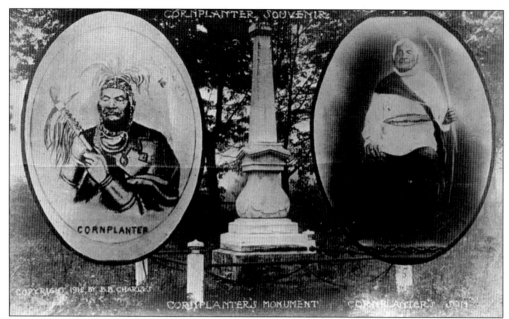

This "Cornplanter Souvenir" postcard shows images of an older Cornplanter, the Cornplanter Monument on the Cornplanter Tract, and Cornplanter's son, Charles O'Bail, who was born around 1780 and died before 1871. Cornplanter was the son of a Seneca woman and the Dutch trader John O'Bail or Abeel and was sometimes called Captain John O'Bail, the surname taken by his descendants. The monument was moved to Riverview Cemetery in 1964 due to the eventual flooding of the Cornplanter Tract by Kinzua Dam.

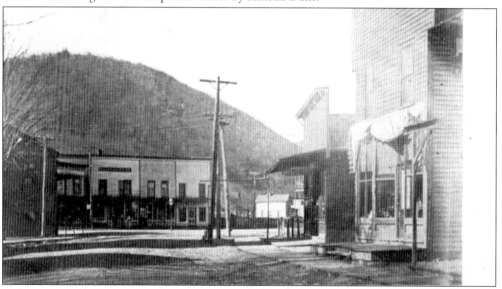

Shown above is a view of the village of Kinzua, formerly located on the confluence of Kinzua Creek and the Allegheny River just north of Warren and the "Big Bend" of the river. In the early 1900s, Kinzua had around 600 inhabitants, many of whom were employed at the local sawmill or the wood chemical plant owned by the Kinzua Chemical Company. Kinzua is a corruption of a Seneca word that either means "they gobble," referring to plentiful wild turkey, or "place of many fishes."

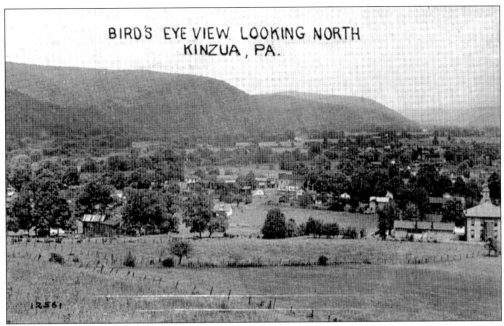

BIRD'S EYE VIEW LOOKING NORTH
KINZUA, PA.

12561

These two postcard views are of the Kinzua Valley, the top postmarked 1942 the lower dated 1929. The sender of the top card, Vina Adams, writes, "This is a view of Kinzua, the school house on the hill is where I got my 'learning' and just below the school house a little to the right is where my father's home stands. Sorry the house is not in this picture." Perhaps the house of Adam's father is at right center in the lower image.

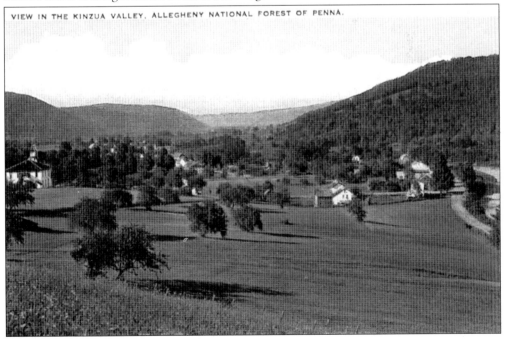

VIEW IN THE KINZUA VALLEY, ALLEGHENY NATIONAL FOREST OF PENNA.

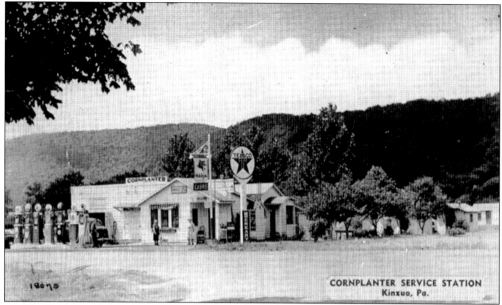

CORNPLANTER SERVICE STATION
Kinxua, Pa.

This Silvercraft postcard shows the Cornplanter Service Station near Kinzua in the 1940s. Located on the Allegheny River at the junction of Routes 59 and 159, the service station was a popular tourist stop with "cabins, showers, and lunches." The caption on the back of the card boasts a variety of petroleum products including "Keystone, Electro, Tydol, Texaco, Mobile, and Kendall Gasolines and Oils." Note the wealth of gas pumps in the bottom left corner of the image.

Upstream from Kinzua, Kane lies on a triple divide with drainage to the north by Kinzua Creek, to the southwest by Tionesta Creek, and to the southeast by the Clarion River. Kane was founded in 1859 by Gen. Thomas L. Kane, who commanded the Pennsylvania Bucktails, an elite sharpshooter unit, during the Civil War. In the early 1900s, Kane was an important oil and gas center and railroad hub with a population of 8,000.

Among its numerous distinctions, Kane was considered the summer vacation place for those who suffer from hay fever and other allergies. This card, showing the "Lakes to Sea Highway Near Kane," notes an "Altitude over 2,000 feet" and "Positive Relief from Hay Fever and Asthma." A 1940 travel guide boasts that Kane has "a rigidly enforced local ordinance against weeds [which] has attracted many sufferers from asthma and hayfever."

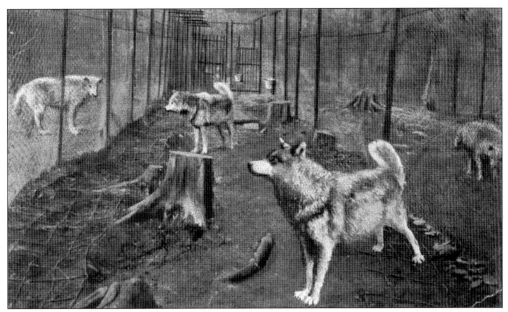

As a child, E. H. McCleary of Kane dreamed of having a wolf as a pet. When he became a physician, McCleary started his own wolf rescue in 1921. He focused on "lobo or buffalo" wolves from the western United States. The wolves were persecuted by ranchers and the federal government. McCleary brought the wolves to his compound located between Kane and Mount Jewett. The "Lobo Wolf Pack" became a tourist stop on the Roosevelt Highway and was "visited by thousands each year" as noted in this card, postmarked 1942.

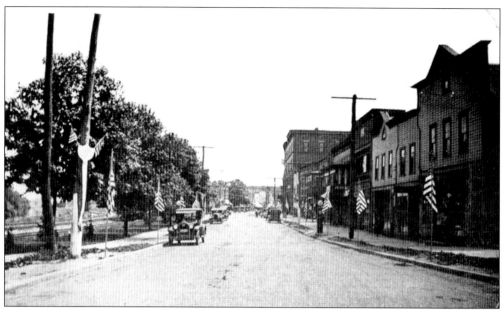

Mount Jewett, upstream from Kane, was also on a triple divide with drainage to the south and east on Potato Creek, to the north on Kinzua Creek, and to the southwest on the Clarion River. In the early 1900s, Mount Jewett was an industrial and railroad town with at least eight railroads leading from it. This view of Main Street, postmarked 1925, appears to have been taken during the Fourth of July, given all the flags.

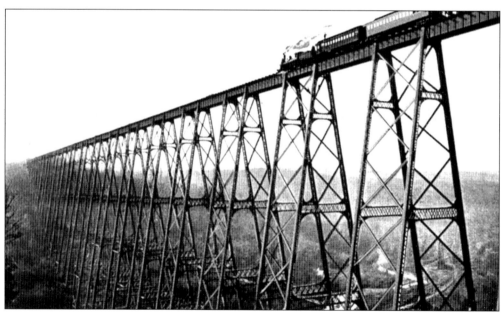

The Kinzua Bridge, northeast of Mount Jewett, was a marvel of engineering. Built in 1882, it stood 301 feet above the Kinzua Creek and spanned 2,053 feet of the valley's width. The original iron structure was rebuilt with steel in 1900 to handle heavier trains and loads. Freight traffic was discontinued in 1959, and in 1963, the bridge and surrounding acreage were designated a state park. On July 21, 2003, an F1 tornado hit the bridge and leveled 11 of its 20 support towers.

Two

THE CONEWANGO VALLEY

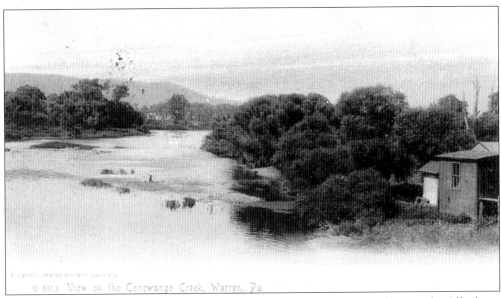

Conewango Creek, flowing south from Cattaraugus County, New York, joins the Allegheny River at Warren. In 1749, the Céloron expedition portaged from Lake Erie to Lake Chatauqua and then descended the Conewango to the Allegheny River. The expedition's goal was to claim the Ohio Valley for the French, an act that raised the ire of the British colonies, especially Pennsylvania and Virginia. At the mouth of the Conewango, under a large red oak, the expedition buried the first of several leaden plates that claimed the land for France.

The state hospital for the mentally ill was built two miles above Warren in the Conewango Valley in 1873. As described in 1886, the hospital was ". . . about 1,200 feet long, practically four stories high . . . [consisting of] . . . a central building devoted to officers, reception-rooms, quarters for superintendents and medical staff, steward's office and rooms, pharmacy, sewing room, chapel, and amusement hall." The Conewango near the state hospital was also a popular recreation spot for boaters, as seen in the lower card postmarked 1907.

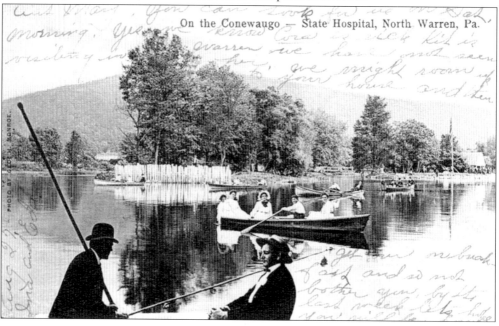

On the Conewaugo — State Hospital, North Warren, Pa.

This postcard, postmarked 1910, depicts the slack-water nature of the upper Conewango Creek in New York. The sender of this postcard, Bess, writes to Girlie: "This picture shows the Flats on my aunt's farm. Along the banks grow forget-me-nots, tiger lilies, and brown-eyed daisies." The Céloron Expedition floated this section of the Conewango in July 1749, paying scant attention to the flora. Their concern was that "The water suddenly gave out under our canoes . . . we were reduced to the sad necessity of dragging them over the stones."

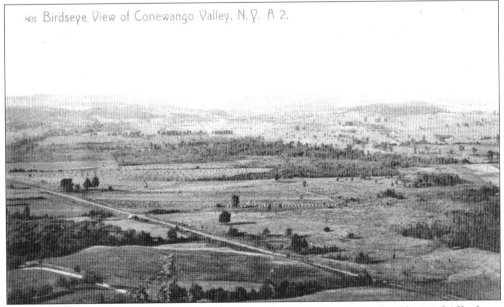

The Conewango Valley in Pennsylvania and New York lies largely on the Glaciated Allegheny Plateau and has much more fertile soil than does most of the Northern Allegheny Watershed, which is non-glaciated. This birds-eye view of Conewango Valley, New York, on the border of Chautauqua and Cattaraugus counties, shows a mosaic of woodlots, pastures, and farm fields typical of a rich agricultural area. The Krieger Drug Store of Salamanca sent this card to customers in 1909 as a reminder to buy school supplies for the coming year.

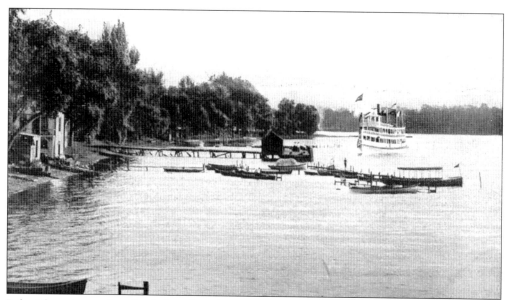

Lake Chautauqua, six miles in length and one to four miles wide, lies 1,308 feet above sea level. Just six miles from Lake Erie, Lake Chautauqua sits 726 feet above it, separated by the Allegheny Divide. Lake Chautauqua was once touted as "the most elevated body of water navigated by steamer upon the American continent." The first steamer on the lake, the side-wheeler *Chautauqua*, was launched in 1828. By 1890, twelve steamers, carrying passengers and freight, plied its waters.

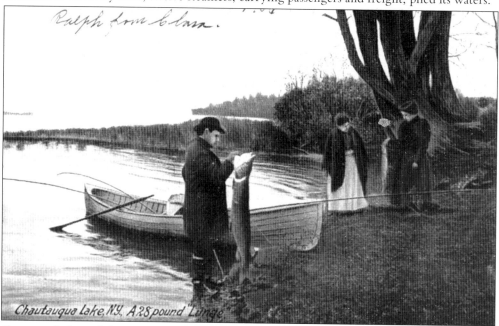

One translation of the Native American name "Chautauqua" is "where the fish was taken out." This postcard published by the H. C. Leighton Company and printed in Germany reads "Chautauqua Lake, NY. A 28 pound 'Lunge.'" The lake has been a destination for recreationists, including boaters and fishers, since the mid-1800s. A travel guide published in 1940 notes "State [Highway] 17 follows the northern shore of Lake Chautauqua through an almost continuous summer resort."

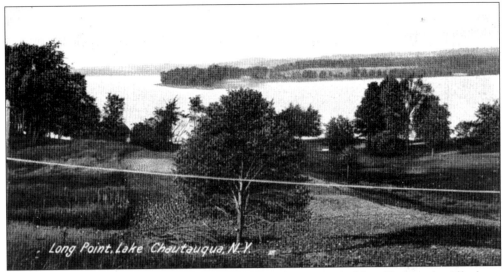

Long Point, Lake Chautauqua, N.Y.

Conewango Creek is the main link between Lake Chautauqua in New York to the Allegheny River in Pennsylvania. The outlet of Lake Chautauqua, the Chadakoin River, joins Cassadaga Creek near Jamestown. Cassadaga Creek meets the Conewango about five miles above the Pennsylvania border. Long Point, shown in this postcard, along with Bemis Point, shown below, juts into Lake Chautauqua near its middle, giving the lake a "wasp-waisted" appearance, hence the other definition of Chautauqua—"bag tied in the middle."

Shore Drive, Bemus Point, Chautauqua Lake, N.Y. 600

In 1874, what became the Chautauqua Institution was founded by Rev. John Heyl Vincent on the shores of Lake Chautauqua. The institution's inaugural assembly was a two-week training session for Sunday school teachers. Two hundred attended the event, living in tents and cottages on a former Methodist camp meeting ground. The Sunday school expanded into a lyceum, and in 1876, a Scientific Congress was held by the institution, a historic and open-minded move by a predominantly religious assembly.

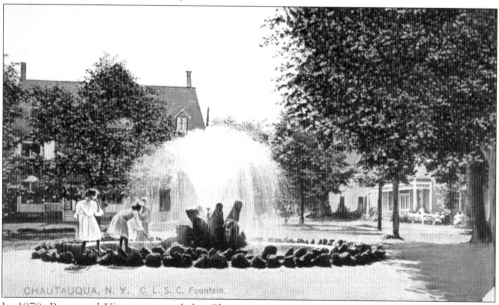

CHAUTAUQUA, N. Y. C. L. S. C. Fountain.

In 1878, Reverend Vincent started the Chautauqua Literary and Scientific Circle, which was the first guided home-study program in the United States. In its first decade, nearly 80,000 people enrolled, predominately from rural areas. The institution grew from a few tents to a "veritable city" which included a 7,000 seat amphitheater, public halls, hotels, and over 500 private Victorian homes. The sender of this postcard postmarked 1908 writes, "My Dear Belle . . . This is the place for all good people."

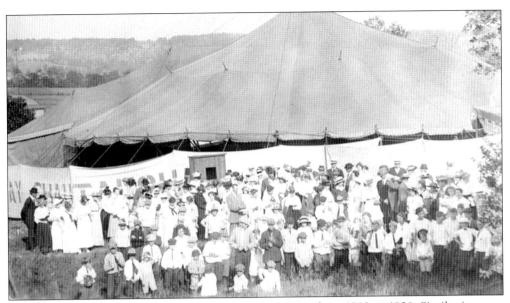

The Chautauqua tent circuits flourished in rural America from 1903 to 1930. Similar in name and programming, the mobile Chautauquas were not affiliated with the Chautauqua Institution. Nor did they emphasize religion or spiritual ideals as most institute programs did. Programs might include orators such as William Jennings Bryant, magicians, bell-ringers, or Shakespearean actors. The Chautauqua tent circuits were known for their trademark brown tents pictured in the image above.

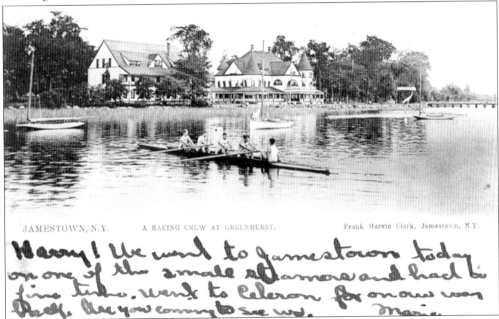

Boating and sailing have been popular on Lake Chautauqua for generations. This view of "A Racing Crew at Greenhurst," postmarked 1908, shows a crew of young men training on the north side of the lake, opposite Jamestown. Sailing boats are anchored near the shore where a Victorian boat club stands. The message on the card reads, "Harry! We went to Jamestown today on one of the small steamers and had a fine time."

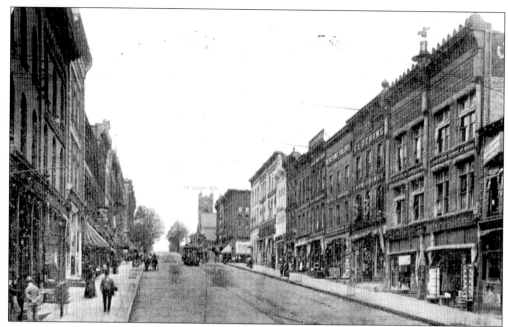

Jamestown is located on the outlet of Lake Chautauqua. Jamestown is named after James Prendergast who settled here in 1811. In the early 1900s, Jamestown had a population of about 26,000 and was the center of the region's furniture industry. This view of Main Street, north from Second Street, postmarked 1906, shows part of Jamestown's business district.

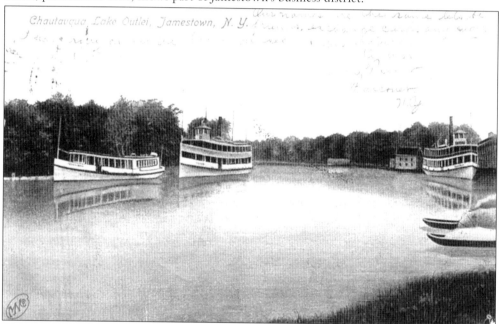

The outlet of Lake Chautauqua, the Chadakoin River, is about 75 feet wide at its mouth. The Céloron Expedition entered the Chadakoin River on their descent to the Allegheny River from Lake Chautauqua on July 24, 1749, reaching the Allegheny five days later. This card, postmarked 1907, shows the "Chautauqua Lake Outlet" with a number of steamers at anchor. The sender of the card writes, "I have been on all the boats you see in this picture."

Three

THE
BROKENSTRAW VALLEY

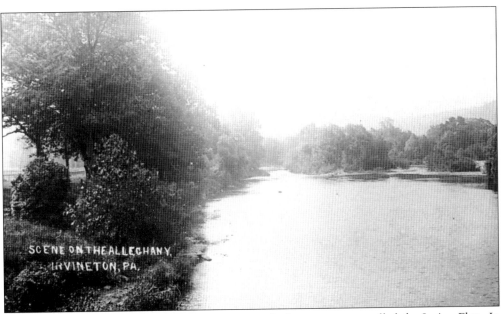

Brokenstraw Creek meets the Allegheny River at Irvineton, an area called the Irvine Flats. In 1785, Gen. William Irvine traveled north along the Allegheny River to seek "Donation Lands" that would be given to Revolutionary War veterans by the state. He noted that the "Brokenstraw is thirty yards wide, there is a fine situation and good bottom near the mouth on both sides . . . a little way up the creek large hills covered with pine make their appearance." Irwin would later acquire much of "this fine situation."

Brokenstraw Creek is reputedly named for a tall grass that grew in the bottoms and covered the ground when it died in the winter. A Native American village, called "Buckaloons" by the English and "La Paille Coupeé" by the French, was situated on the Irvine Flats. Father Bonnecamps of the Céloron Expedition described the village in 1749 as "very insignificant . . . composed of Iroquois and some Loups [Delawares]." Buckaloons was destroyed in 1781 by an American force under Col. Daniel Broadhead.

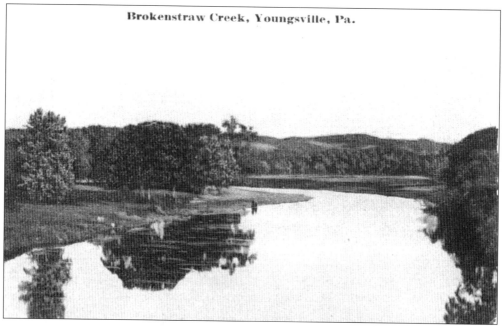

Brokenstraw Creek, Youngsville, Pa.

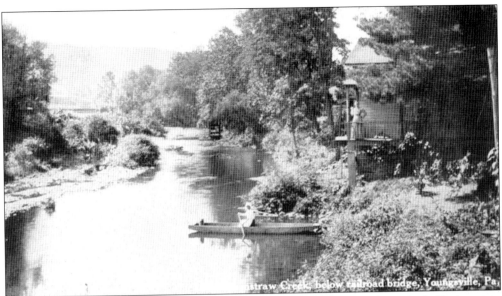

The white pine noted by General Irvine in 1785 was the basis of the first industry in the Brokenstraw Valley—the floating of pine timber to market. Darius and Joseph Mead began lumbering on the Brokenstraw in 1801, and by 1805, a new trade emerged—the floating of seasoned lumber from Brokenstraw to New Orleans. The view shown above, postmarked 1908, depicts a more serene, carefree time on the Brokenstraw near Youngsville.

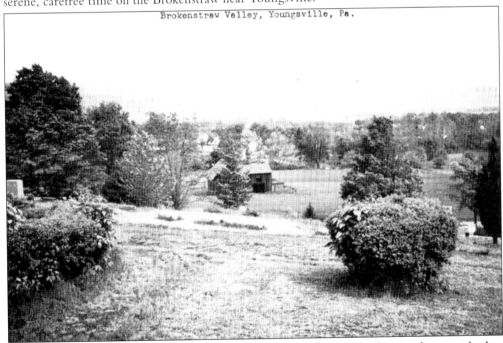

After the prime timber was removed from the Brokenstraw Valley, farming became the key livelihood for residents. A 1915 survey of the Brokenstraw Valley noted that "This stream flows through a fertile, rolling, farming country [with] easily worked fertile soils . . . farming and grazing is largely practised throughout the watershed." The image above shows a pastoral scene in the Brokenstraw Valley near Youngsville.

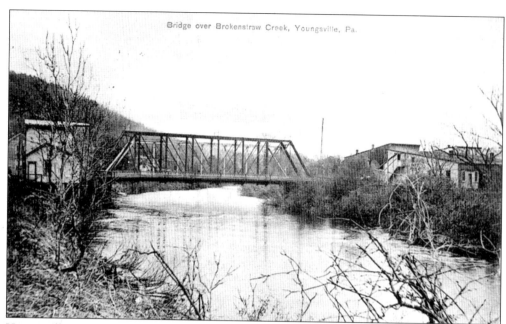

Bridge over Brokenstraw Creek, Youngsville, Pa.

Youngsville was incorporated in 1849 and was named for Matthew Young, who "pitched his tent" on the future town's site in 1796. This card, postmarked 1910, bearing the caption "Bridge over Brokenstraw Creek, Youngsville," was published by J. W. Agrelius and was made in Germany. Agrelius became a merchant in Youngsville in the 1870s. By 1887, he was dealing in "a stock of drugs and medicines valued at $8,000."

VIEW ON THE BROKENSTRAW
YOUNGSVILLE, PA.

The first gristmill in Warren County was built by Darius and Joseph Mead on the Brokenstraw in 1801. In 1915, a state survey remarked that Brokenstraw Creek "has a very persistent flow in periods of drought and is perhaps in this respect the most remarkable of any tributary of the Allegheny River." This explains historian J. S. Schenck's comment that "in dry times some grists came forty miles" to the Mead mill.

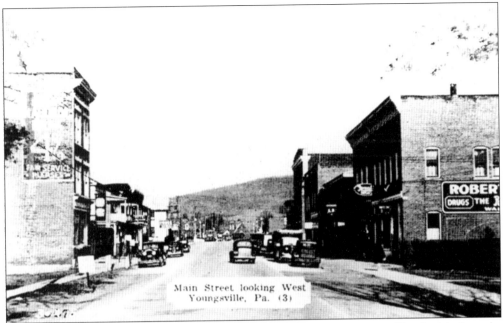

Main Street looking West
Youngsville, Pa. (3)

The card above, postmarked 1945, shows a view of Main Street, Youngsville. At this date, the town had a population of around 1,900 and was described as a "one-street mountain town [that] produces a colored shale brick, furniture, and mirrors." The Forest Furniture Factory, shown below on Brokenstraw Creek, is one of the "two furniture factories, three planning mills, and two brick yards" that operated in Youngsville in 1915.

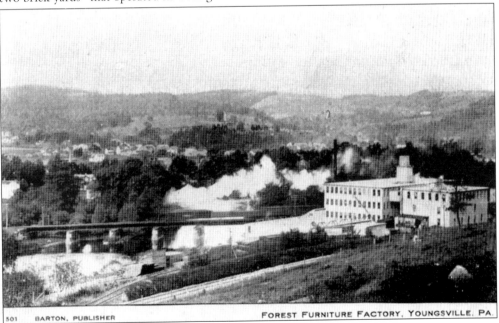

501 BARTON, PUBLISHER FOREST FURNITURE FACTORY, YOUNGSVILLE, PA.

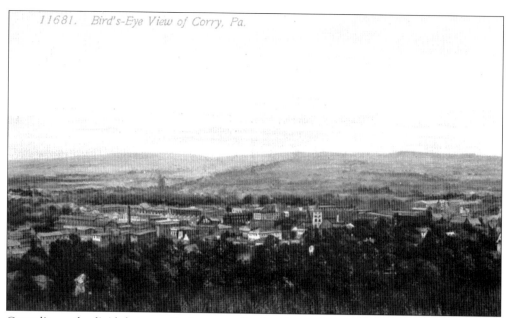

11681. Bird's-Eye View of Corry, Pa.

Corry lies on the divide between Brokenstraw Creek and French Creek in the extreme northeastern portion of Erie County. Corry was founded in 1861 when the right-of-ways of two railroads met at Hiram Corry's farm. Buoyed by the discovery of oil near Titusville, 25 miles south, Corry boasted two hotels, an oil works, and several mills by 1862. Clearing for the town happened so rapidly that Corry became known as "the city of stumps."

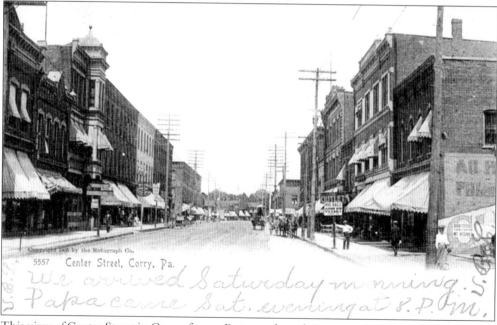

5557 Center Street, Corry, Pa.

This view of Center Street in Corry, from a Rotograph card, is postmarked 1906. In 1915, Corry was a prosperous community with a population of 7,500 supported by nearly 30 industries and served by three railroads. The most important industries of the time were the locomotive works of the Climax Manufacturing Company, the U.S. Radiator and Boiler Works, and the Ajax Iron Works. The large Howard and Company tannery was located just east of the town.

Four

THE OIL CREEK VALLEY

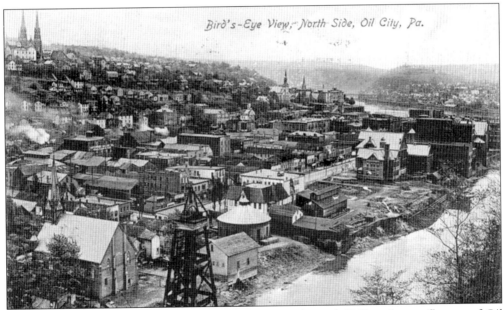

When oil was discovered in large quantities in the Oil Creek Valley, the confluence of Oil Creek and the Allegheny River became an important staging area for the transport of oil to Pittsburgh. Oil City, built on this key confluence, grew quickly during the early oil boom to become an important center of western Pennsylvania's petroleum industry. By 1862, fifteen steamers and towboats and nearly 300 flatboats were carrying Oil Creek crude from its source to markets in Pittsburgh.

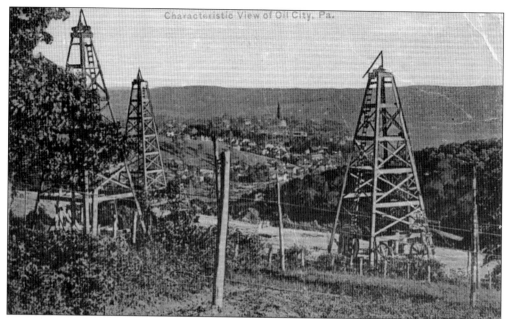

Oil City had few producing wells in its bounds, but four miles up the Oil Creek Valley toward Rouseville the wells, crowned by derricks like these shown in these two postcards, increased greatly in number. J. R. G. Hazzard, a correspondent for the *New York Daily Tribune*, traveled Oil Creek in 1868 noting, "The bottomlands are . . . a wilderness of derricks which remind you of . . . shipping crowded into some great harbor."

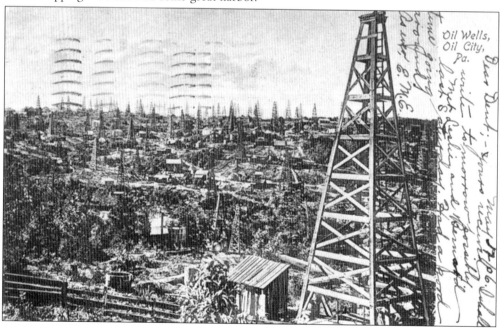

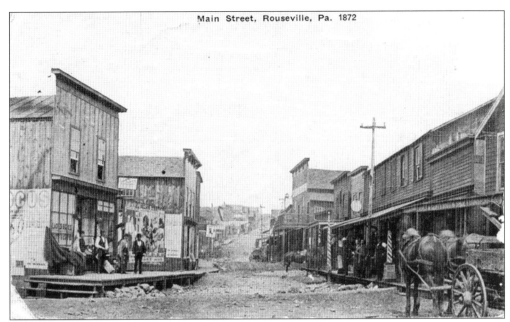

Main Street, Rouseville, Pa. 1872

Henry R. Rouse was an energetic Warren County schoolteacher, lumberman, and legislator who sunk the third well in Pennsylvania on the Buchanan Farm in 1859, later to become Rouseville. Rouse was killed in a well fire in 1861, leaving much of his wealth in trust to Warren County. This image of Main Street, Rouseville, in 1872 was taken by Miriam Ackley. The card was published by A. N. Rose, Rouseville.

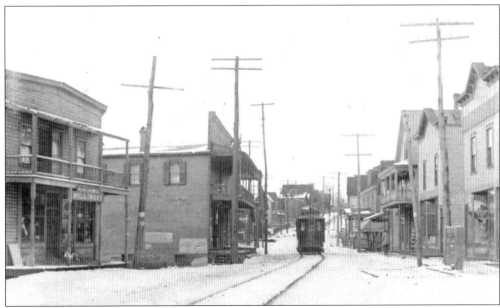

In 1915, Rouseville had a population of 700. There were two refineries in town: the Germania Refining Company with 50 employees and the Crystal Oil Works with 18 employees. Germania Refining merged with Penn Refining in 1914, keeping the Germania name. In 1917, after the United States entered World War I against Germany, the company changed its name to the Penn-American Refining Company in response to prejudice against anything "German."

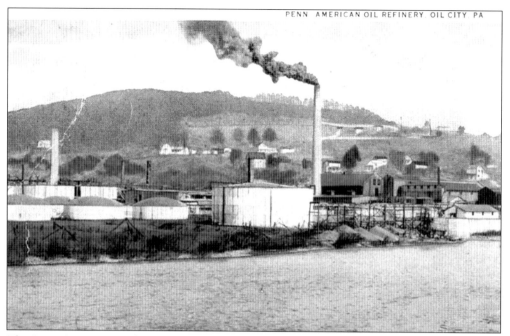

The Penn-American Refining Company, whose refinery appears above, merged with Pennzoil affiliates to become Pennzoil in the 1920s. The Pennzoil Refinery at Rouseville, depicted in the linen card below, was among the largest in Pennsylvania in 1940. It made a variety of products from crude oil, ranging from wax to gasoline, by the process of fractionalization. Multiple distillation by heat, steam, or vacuum separated products based on their varying vaporization points.

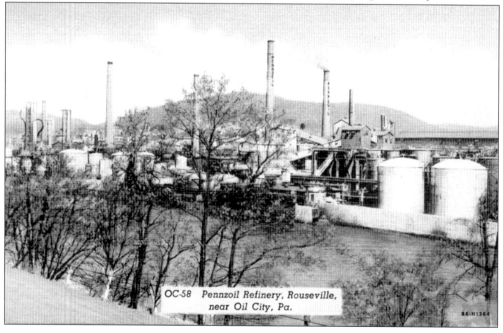

OC-58 Pennzoil Refinery, Rouseville, near Oil City, Pa.

Life in the Oil Creek Valley changed dramatically on August 27, 1859, when a well drilled by Edwin L. Drake struck oil. The photograph on this card was taken by John Mather, oil field photographer, in 1861. Although titled "The Original Drake Well," the image is of the second well, rebuilt after a fire. Drake is the man in the right foreground. Titusville druggist Peter Wilson, a local supporter of Drake's project, is at Drake's left.

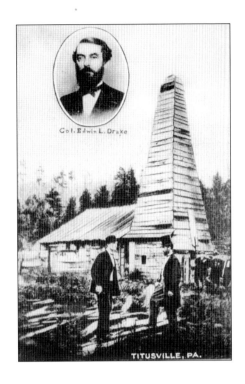

Oil fever struck the Oil Creek Valley after Drake's success. This card by the Drake Well Museum shows "Wells on Cow Run, near Shaffer Farm, Oil Creek Valley, Pa, 1860s." Twenty-four wells, of which eight were failures, were sunk along the flats and slopes of Oil Creek at George Shaffer's 50-acre farm. In 60 days, the farm that consisted of a single house and barn grew to a town of 3,000.

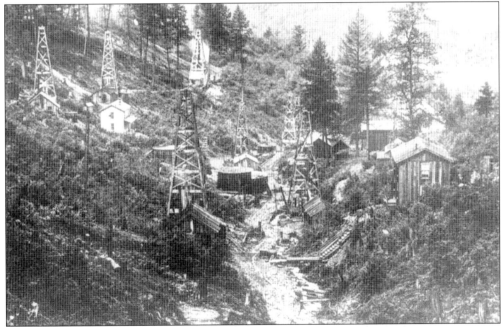

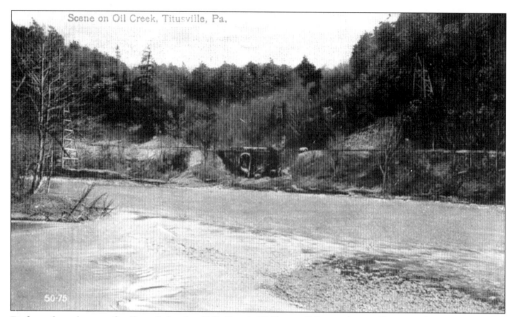

Scene on Oil Creek, Titusville, Pa.

Before the advent of railroads in the Oil Creek Valley, oil from the wells on Oil Creek, as well as passengers, was transported by wagon or packet boat to Oil City. The Oil Creek Railroad reached Titusville from Corry in 1862. By 1864, it had reached Shaffer Farm. Ultimately, the railroad, renamed the Oil Creek and Allegheny River Railroad, would connect Titusville with Oil City. The card above shows a railroad bridge spanning a small run on Oil Creek.

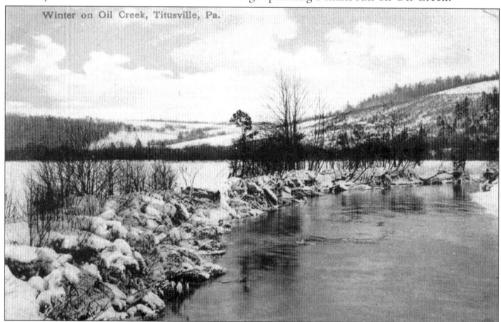

Winter on Oil Creek, Titusville, Pa.

Ice formation was common on Oil Creek in the winter months, sometimes with disastrous effects. While ice impeded packet boat travel downstream, frozen roads meant that teams moving barrels of oil would not be bogged down in mud. Teamster S. W. Peabody noted an "ice gorge . . . about one mile long above Rouseville on 1 March 1865." By March 17, a flood was "a-raging on Oil Creek, floating away about 15 thousand barrels from Shaffer Farm."

A significant advance in oil transport was the pipeline, connecting wells to a central collection site. The first oil pipeline, two miles in length, was built in 1863, linking Tarr Farm on Oil Creek to the refinery at Plumer. Initially, "force pumps" were used to move the oil through wrought-iron pipes, but later pipelines were often gravity-fed. Development of pipelines led to the "technological unemployment" of teamsters, sometimes leading to violence.

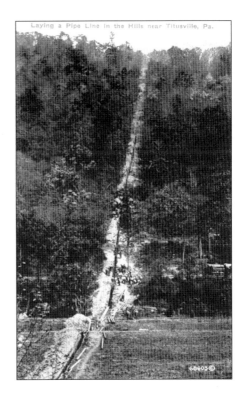

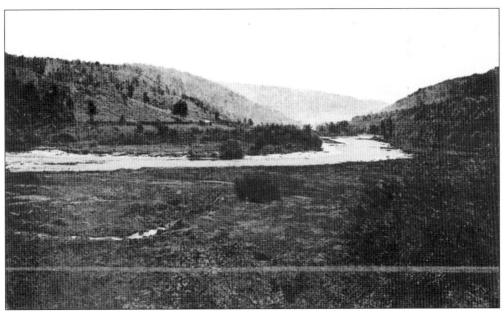

In 1882, oil production began to decline in the Oil Creek Valley. This card shows a view of the Oil Creek Valley near Titusville, around 1897, recovering from the oil boom. The valley here is about a mile wide. Oil production had initially focused on the bottomlands of Oil Creek as drillers believed that oil gathered mainly along streams. A watershed survey from the early 1900s noted that Oil Creek's "bottom-lands are mostly waste."

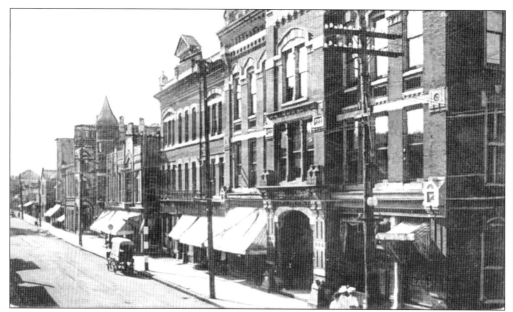

Edwin Drake first visited Titusville in 1857, when it had a population of 125, no churches, and two hotels. By the early 1900s, Titusville's population had reached 10,000, with extensive industries including three oil refineries, steel works, four iron working establishments, paraffin works, soap works, and the Elk Tanning Company's Queen City Tannery. This view of "West Spring Street, Titusville, Pa," postmarked 1909, shows a prosperous business sector.

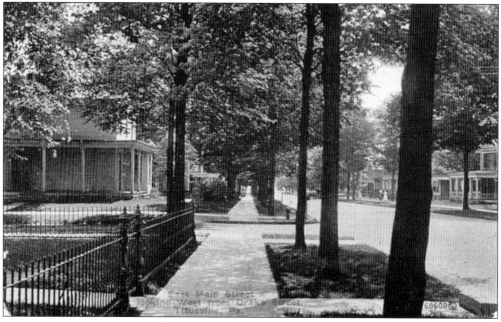

The residential areas of Titusville were clean, tidy, and picturesque in the early 1900s as seen in this card of "East Main Street Looking West from Drake Street," postmarked 1912. By 1940, the Works Project Administration noted that "The romance of its early days has departed Titusville . . . The wealthy oil men . . . have long since left the scene . . . though a number of mansions remain . . . many of them are in need of repair."

Five

THE FRENCH CREEK VALLEY

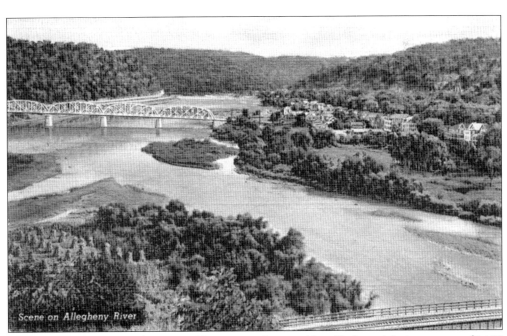

Scene on Allegheny River

French Creek rises in southwestern Chautauqua County, New York, and drains an area of 1,180 square miles including parts of Erie, Crawford, Mercer, and Venango counties, Pennsylvania. It meets the Allegheny River at Franklin. Franklin, like Warren to the north, was surveyed in 1795 under the direction of Commissioners Andrew Ellicott and Gen. William Irvine. The town was named in honor of Benjamin Franklin.

The junction of French Creek and the Allegheny River was a strategic military location. The French built Fort Machault here in 1753 but abandoned and burned it in 1759 after the fall of Fort Niagara. In 1760, nearby, the British built Fort Venango, which fell during Pontiac's Rebellion in 1763. In 1787, the Americans built Fort Franklin on the south bank of French Creek and kept a garrison there until 1796. This card shows a reconstructed blockhouse, probably of Fort Franklin, on French Creek.

Like the succession of forts at its mouth, French Creek has been given many names over the centuries. The Native American name for the stream was "Onenge," meaning "the otter." This was corrupted to "Venango" by the British who called the stream the Venango River. The French called the stream the "Riviere au Boeufs," perhaps the "river of buffalo" or "beef." The contemporary name was given to the stream in 1753 by George Washington, who called it "French Creek."

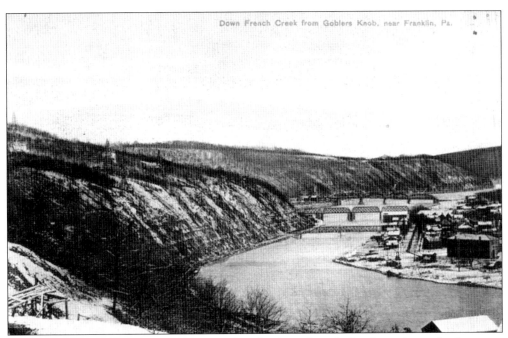

The industrial sector of Franklin grew up largely along French Creek, as shown in these two postcards. In the early 1900s, industries as diverse as steel works, pneumatic tool works, rolling mills, brass foundries, manifold works, machine shops, flour mills, and plants for manufacturing railway and oil well supplies occurred along French Creek.

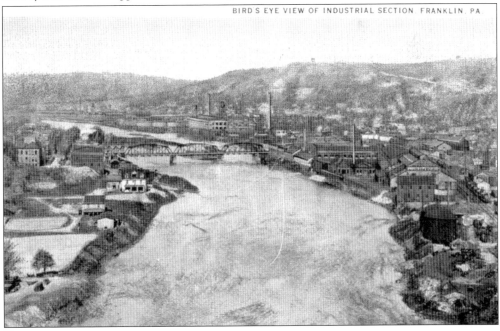

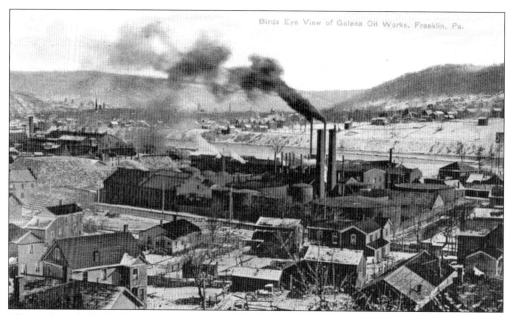

The Galena Oil Works was relocated to the old Dale Refinery on French Creek in Franklin after the original factory burned in 1870. The company's name came from the lead sulfide used in the refining process, which gave the oil unusual endurance as a lubricator. Galena was sold to Standard Oil in 1878. By 1895, Galena oils lubricated 95 percent of the railroad mileage in North America and Mexico.

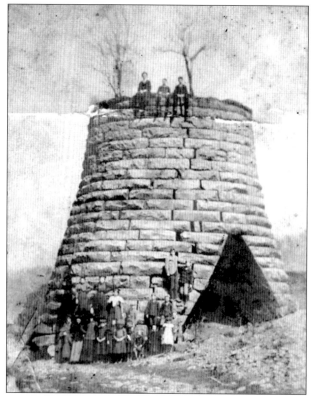

Valley or Orleans Furnace was a charcoal iron furnace, built in 1845 or 1848, that stands near Wyattville, Venango County. Several charcoal iron furnaces were in blast near Franklin from the 1830s to the 1850s, providing considerable trade for the town. Valley Furnace is unusual in that it is a round furnace of cut stone while most furnace stacks of the time were of a pyramidal shape. Valley Furnace was in blast until at least 1853.

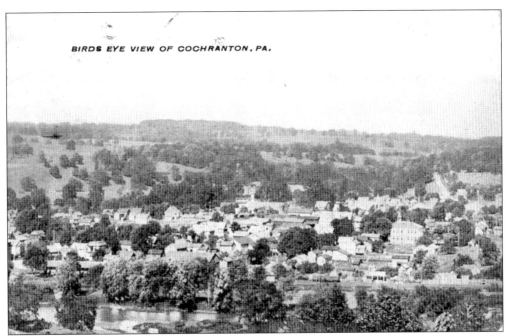

BIRDS EYE VIEW OF COCHRANTON, PA.

Cochranton, in southern Crawford County, had a population of 640 in the early 1900s. At that time, the town's chief industries were "a machine shop, a sawmill, a handle factory, and a grist mill." French Creek was also a draw for vacationers. The sender of the top card, postmarked July 8, 1912 writes, "We are spending a week in a cottage along French Creek. Only fourteen of us."

Franklin St., looking South. Cochranton, Pa.

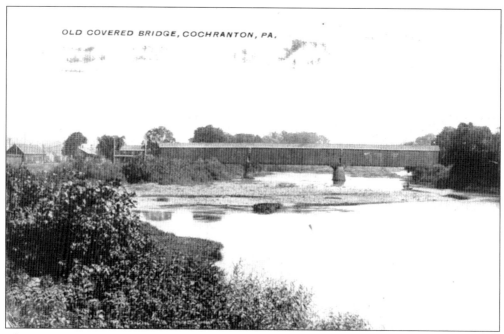

OLD COVERED BRIDGE, COCHRANTON, PA.

This card, postmarked 1911 and published by the National Colortype Company, shows an old covered bridge crossing French Creek at Cochranton. This bridge was replaced in 1930 by a steel truss bridge that stands to this day.

The message on this card, postmarked August 10, 1922, reads, "French Creek is a summer resort a few miles from where we are staying, where we have met a number of people from the hill. The country is the most beautiful we have ever seen. Wish you were here to enjoy it with us." The card was mailed to a Pittsburgh address and the "hill" referred to is probably one of the many locales about the city named hill (e.g., Squirrel Hill, Penns Hills, and Forest Hills).

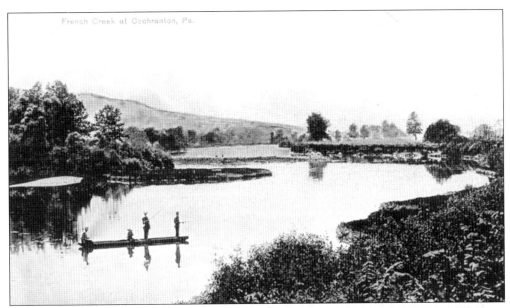

French Creek is celebrated as one of the most biologically diverse streams in the Northern Allegheny Watershed, supporting a unique array of fish and mollusk species. Not surprisingly, fishing has always been a time-honored endeavor on French Creek, as shown in the card above in which fishers float on placid waters amidst a verdant pastoral landscape. This card, of the H. H. Hamm series, was made in Germany and published and imported by G. A. Peters of Cochranton.

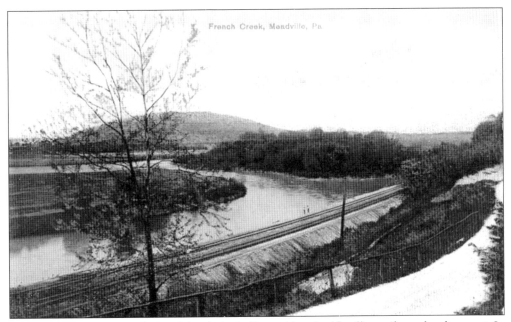

The broad valley of French Creek is relatively flat and lent itself well to railway development. In the early 1900s, over 120 miles of rails traversed the French Creek Valley, linking Franklin and Meadville to points beyond. Lines included the Western Division of the Pennsylvania Railroad, the main line of the Erie Railroad, and the Franklin Branch of the Erie, among others. This card shows the Franklin Branch following French Creek toward Meadville.

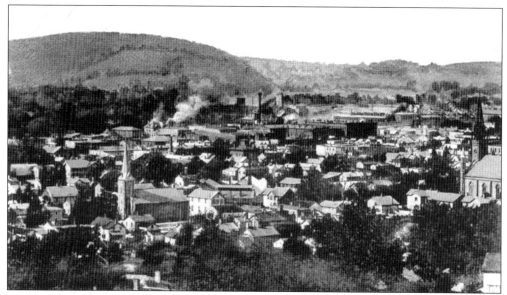

Meadville, the Crawford County seat, was named for David Mead, a Revolutionary War ensign, who settled here in 1788. Meadville was established on the site of a Munsi Delaware village named Cussewago after the creek of the same name. Moravian minister John Heckewelder visited Meadville in 1800 and noted that it "consists of about 40 houses . . . There are several good stores and also some good taverns. The situation, on a high bank of French Creek, affords a fine view."

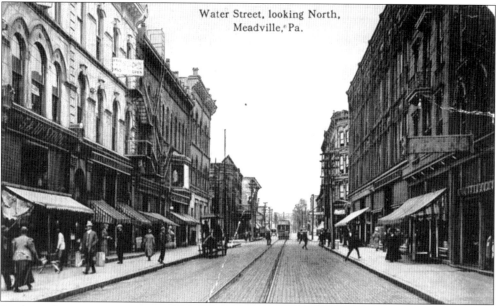

By the early 1900s, Meadville had a population of over 15,000, the largest in the French Creek watershed. Unlike Franklin, Meadville was not an industrial center being instead "a residential center in an agricultural district." The Phoenix Iron Mills and the Meadville Malleable Iron Company were the largest industries. Smaller industries included boiler, vice, tool, and corset works, a distillery, a brewery, a sawmill, and a gristmill. This view of Water Street, postmarked 1915, shows a prosperous business sector.

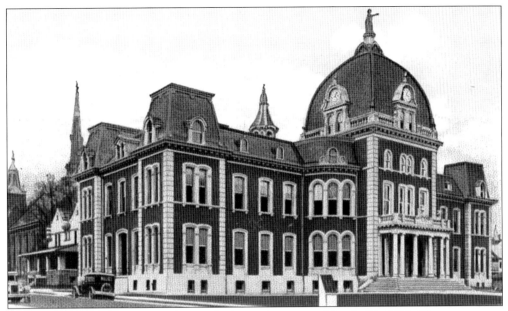

Crawford County was formed from Allegheny County on March 12, 1800. The county was named after William Crawford, a Revolutionary War colonel, surveyor, and friend of George Washington, who was burned at the stake by Native Americans near Sandusky, Ohio, in 1782. The Crawford County Courthouse, pictured on the card above, was built in 1857, an example of Second Empire architecture, with a mansard roof and prominent clock tower.

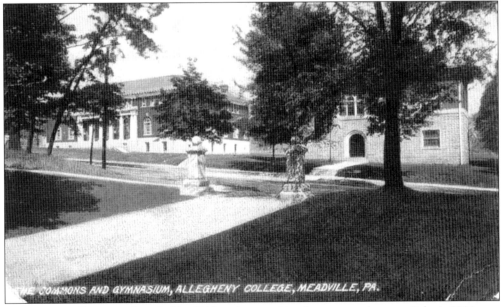

Allegheny College was founded in 1815 and opened its doors to students on July 4, 1816, as a seminary. The Reverend Timothy Alden was installed as the first president and professor of languages and ecclesiastical history. Reverend Alden was an untiring man who combed the eastern states for aid for the new college. He was especially successful in securing rare book collections. The card above, postmarked 1909, shows "the Commons and Gymnasium, Allegheny College, Meadville, PA."

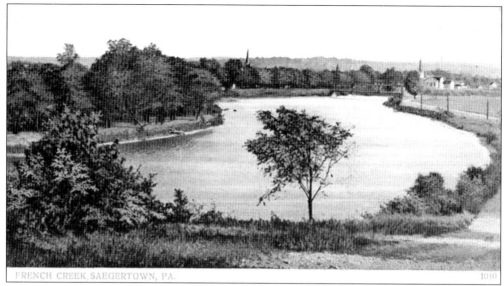

FRENCH CREEK, SAEGERTOWN, PA. 1010

Saegertown, a small borough north of Meadville on French Creek, had a population of nearly 1,000 in the early 1900s. Saegertown's sole industries at the time included the Saegertown Inn, a health resort with mineral springs and a bottling plant, a flour mill, and the Crawford County Home with 92 "inmates." The card above, "French Creek, Saegertown, PA," was published by A. C. Bosselman and was made in Germany.

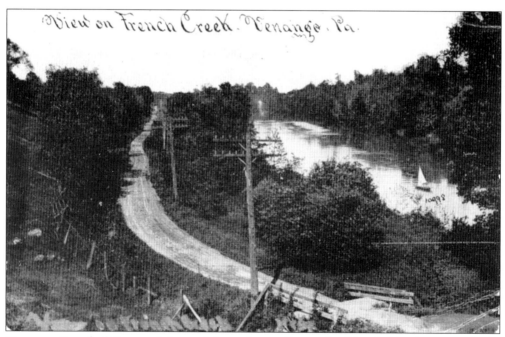

View on French Creek, Venango, Pa.

Venango, Crawford County, is located about three miles south of Cambridge Springs. It had a population of 230 in the early 1900s. There were few industries in the town at the time except for a gristmill and a cheese factory with eight employees. The card above, postmarked 1912, is captioned "View on French Creek, Venango, Pa." Note the small sailboat plying the slow waters of French Creek.

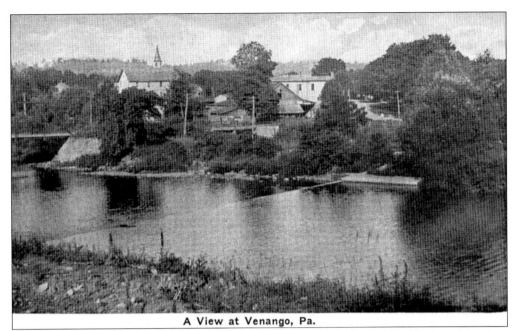

A View at Venango, Pa.

The card above, postmarked 1928, is captioned "A View at Venango, Pa." This sky-tinted card was published by the Auburn Post Card Manufacturing Company of Auburn, Indiana. The sender of the card writes, "We have a very nice cottage. Edith and I hiked up here to get groceries. There is a wonderful place for the roast. Well, don't work too hard."

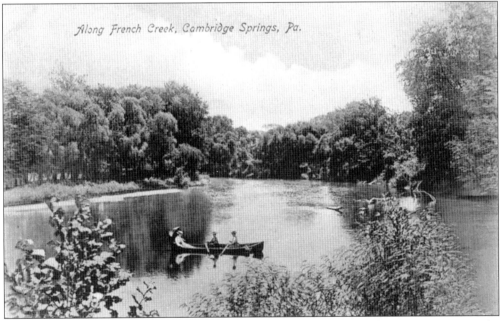

Along French Creek, Cambridge Springs, Pa.

Cambridge Springs, Crawford County, was a farming community and summer resort. In the early 1900s, the normal population was about 1,800, swelling to about 4,500 in the summer months. Summer tourists were drawn to the curative mineral springs, often staying at the many large hotels in the town. Cambridge Springs was also home to the Boland and Ross Tannery, which processed 125 hides daily. The postcard above depicts the leisure life on French Creek.

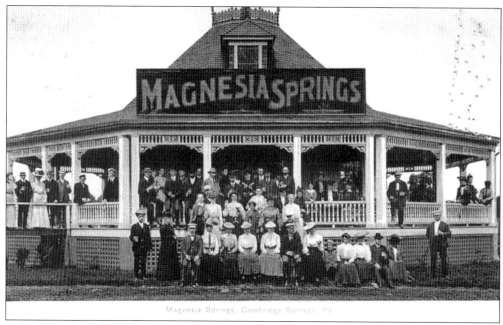

Magnesia Springs, Cambridge Springs, Pa

While prospecting for oil near Cambridge Springs in 1884, Dr. John H. Gray instead discovered a mineral spring. Recognizing a market, Gray advertised the curative values of the water "at a time when people thought a little iron in the water would cure almost anything." By the 1940s, winter recreation facilities were built in the town (a toboggan run, ski trail, and skating rink) to extend the tourist season year round. These cards show Magnesia Springs and the San Rosario Health Resort at Cambridge Springs.

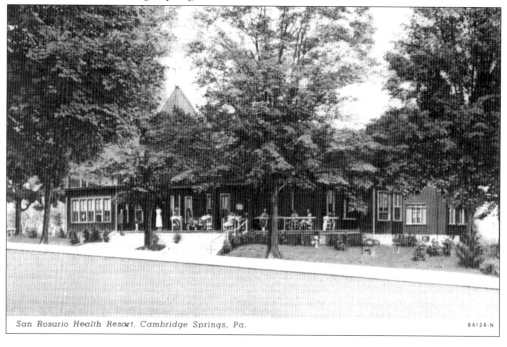

San Rosario Health Resort, Cambridge Springs, Pa. 6A124-N

Six

THE TIONESTA
CREEK VALLEY

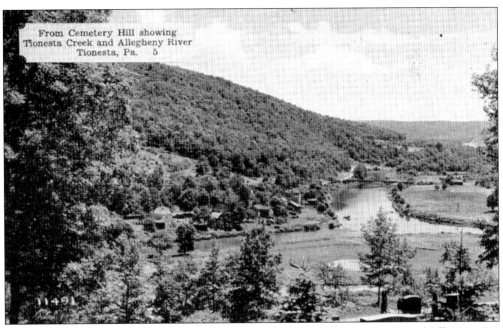

Tionesta Creek rises from three branches originating in Warren, McKean, and Elk counties. The main branch of the creek rises in southeastern Warren County and flows south to enter northeastern Forest County. This card shows the confluence of Tionesta Creek with the Allegheny River at the borough of Tionesta, about halfway between the Allegheny's source and its mouth at Pittsburgh.

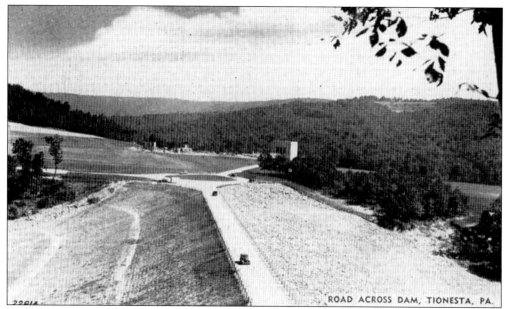

The earthen Tionesta Dam, located about one mile above the junction of Tionesta Creek and the Allegheny River, was begun in 1939 and completed in 1941 by the U.S. Army Corps of Engineers. Tionesta Dam was one of 13 flood control dams proposed for the Allegheny Valley by Pittsburgh's Flood Commission after the destructive flood of 1907. Ultimately, only five dams would be constructed. The card above shows the "Road Across Dam" around the 1940s.

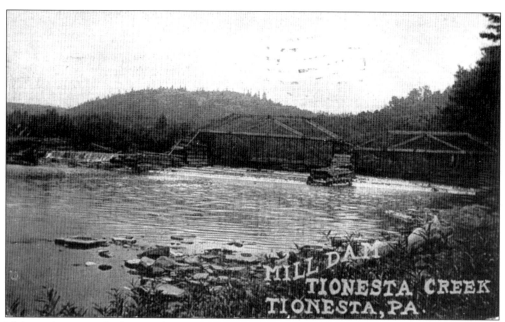

This card, postmarked 1909, shows a view of the "Mill Dam, Tionesta Creek, Tionesta, PA." This may be an image of the timber crib dam built by the U.S. Department of Interior in 1893 to improve navigation on the Allegheny River. The structure was 300 feet in length and 16 feet deep.

The village of Nebraska, at the confluence of Coon Run and Tionesta Creek, was formerly called Fords Mill and Lacytown. Nebraska in its heyday in the 1880s was a lumber town where lumber magnate T. D. Collins owned a reported 50 million board feet of "pine and other timber." The penciled note on the card above reads "Nebraska Stone Crusher," a device that appears to be used for rail bed construction.

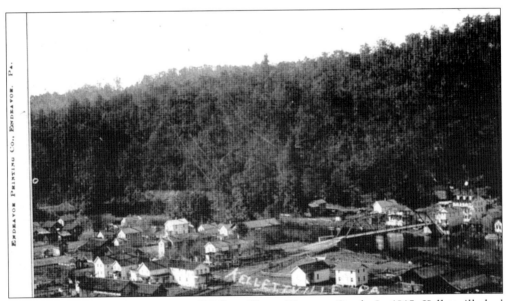

This card shows a birds-eye view of Kellettville on Tionesta Creek. In 1915, Kellettville had a population of 600 with the chief industry being the Elk Tanning Company's tannery. The message on the back of this card reads "that building at the end of this bridge to the right with the three little white windows is our hotel. We only have that one, it is called the Kingsley."

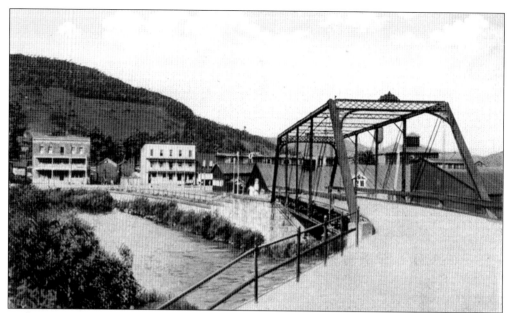

The village of Sheffield was founded around 1864. The first tannery was built here in 1866 by the firm of Horton and Crary, which specialized in the export of "hemlock sole leather" used in shoes. Their income in this endeavor was estimated at $2.5 million per annum in 1880. The hemlock bark for tanning was obtained from the company's land holdings, about 50,000 acres, but many of the hides were rumored to have come from South America.

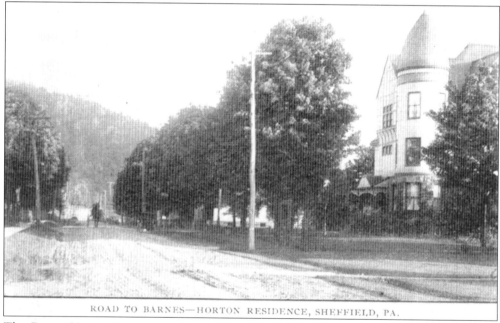

ROAD TO BARNES—HORTON RESIDENCE, SHEFFIELD, PA.

The George Horton House—on the road from Sheffield to Barnes, the current Route 666—is a Victorian icon of Sheffield. It was built in 1889 and represents the Queen Anne–style of architecture. The Horton family moved to Sheffield from Sullivan County, New York. George, Webb, Walter, and Isaac Horton played a major role in building the town, operating its tanneries, saw-mills, and oil wells, the major industries of the time.

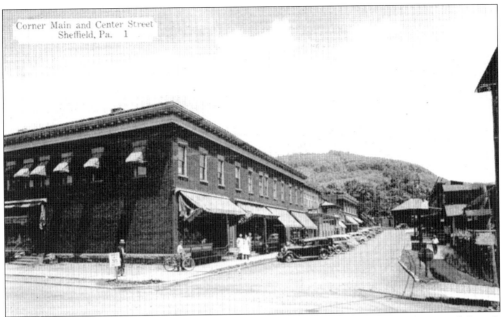

By 1915, Sheffield had a population of 2,500, the largest on Tionesta Creek. Horton and Crary's three tanneries were taken over by the Elk Tanning Company and named the "Horton," the "Tionesta," and the "Sheffield." By 1936, Sheffield's tannery industry crashed. A 1940 travel guide notes that "weedy lots and forsaken gardens dot the town." The card above, "Corner Main and Center Street," shows downtown Sheffield around the 1940s.

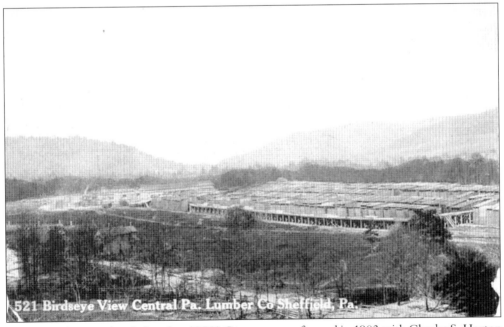

521 Birdseye View Central Pa. Lumber Co Sheffield, Pa.

The Central Pennsylvania Lumber (CPL) Company was formed in 1903 with Charles S. Horton as president. By 1908, the CPL mill in Sheffield was considered among the most modern in the nation, with a capacity of 130,000 board feet in eight to ten hours. CPL was in existence until 1941. This card, postmarked 1915, shows a views of the CPL mill at Sheffield.

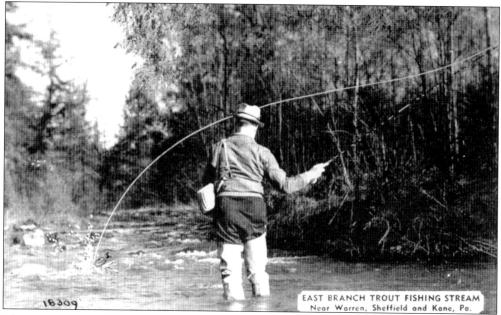

The upper reaches of Tionesta Creek were highly regarded as trout fishing waters as seen in this *c.* 1940 postcard. Seven tanneries were located along Tionesta Creek and its main tributaries in the early 1900s, including three at Sheffield and one each at Brookston, Ludlow, Clarendon, and Kellettville. A survey conducted at the time indicated that Tionesta Creek "was badly polluted by tannery wastes." Luckily, many headwater tributaries of the Tionesta avoided this fate.

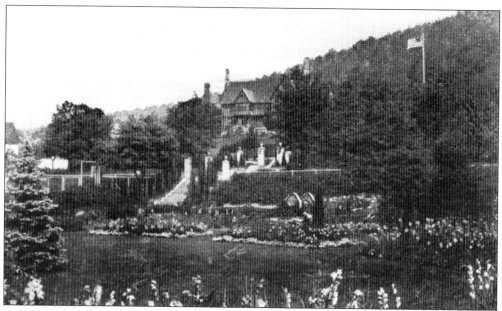

Ludlow, on a tributary of Tionesta Creek east of Sheffield, was also a tannery town. George Welch Olmsted, a successful utilities businessman, built Olmsted Manor in 1917. He commissioned Alling S. DeForest, one of America's foremost landscape architects, to design the "Sunken Gardens" pictured above. The Sunken Gardens was considered stunning in May, when 12,000 red, white, and blue tulips bloomed amid a mass of other flowers.

Seven

THE CLARION
RIVER VALLEY

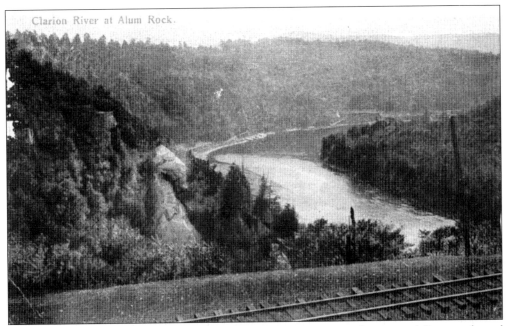

Clarion River at Alum Rock.

The East and West Branches of the Clarion River rise in McKean County and flow southward to meet at Johnsonburg, Elk County. The Clarion River drains an area of 1,175 square miles, including parts of McKean, Elk, Forest, Jefferson, and Clarion counties. The Clarion River meets the Allegheny River near Parker's Landing, Clarion County, 85 miles above the Allegheny's mouth at Pittsburgh.

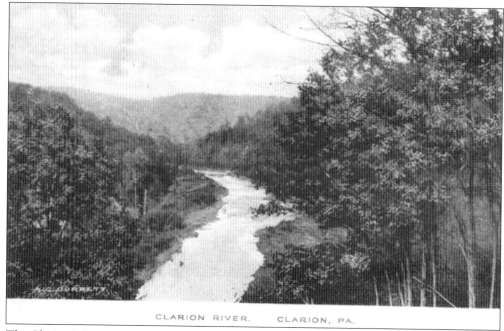

CLARION RIVER. CLARION, PA.

The Clarion River was once called Toby's Creek or Stump Creek. Toby may be a corruption of the Delaware "Topi-hanne" meaning "alder stream." Stump Creek may refer to the lumbering that was occurring on the lower Clarion River in the early 1800s, leaving hillsides of stumps. In 1817, surveyors David Lawson and Daniel Stannard gave the river its present name, from the sound of its ripples that sounded like a "distant clarion."

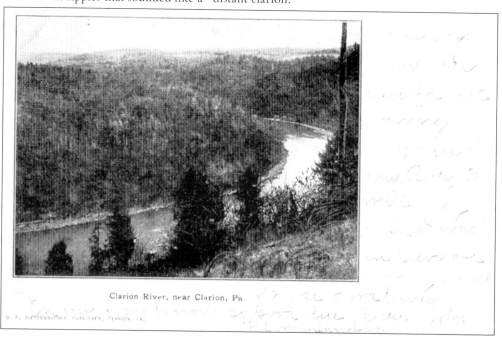

Clarion River, near Clarion, Pa.

Clarion County was formed from parts of Armstrong and Venango counties by legislative act on March 11, 1839. The county derives its name from the Clarion River, which runs prominently through its middle. The county courthouse, located in the county seat of Clarion, was built in 1884. It was designed by architect M. E. Butz in the Queen Anne style. Two courthouses prior to this were destroyed by fire in 1859 and 1882.

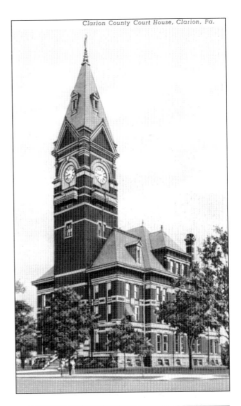

Clarion County Court House, Clarion, Pa.

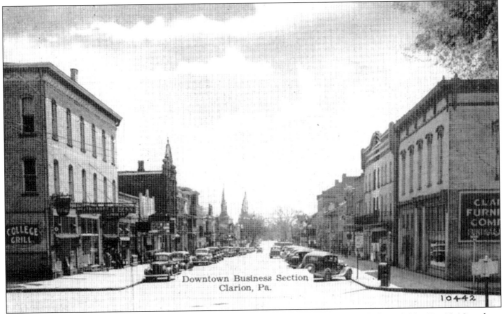

Downtown Business Section
Clarion, Pa.

This card shows the "Downtown Business Section" of Clarion, around the 1940s. In 1940, when Clarion was celebrating its centennial, the population was 3,793. Other Clarion milestones in 1940 included serving as the terminal for the Lake Erie, Franklin and Clarion Railroad; having one of the largest milk bottle factories in the country; and "having ten big garages where automobiles are sold and repaired."

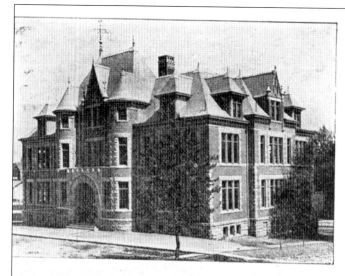

Science Hall, Clarion State Normal School, Clarion, Pa.

2/25/07.

Raymond

D. F. DIEFFENBACHER, PUBLISHER, CLARION, PA.

Clarion is the home of Clarion University of Pennsylvania. Founded as Carrier Seminary in 1868, it became Clarion State Normal School, Clarion State Teacher's College, Clarion State College, and eventually Clarion University in 1983. The card above, postmarked 1907, shows the "Science Hall, Clarion State Normal School," later renamed Founder's Hall. The card below shows the "Campus Entrance to the Clarion State Teacher's College," around the 1940s.

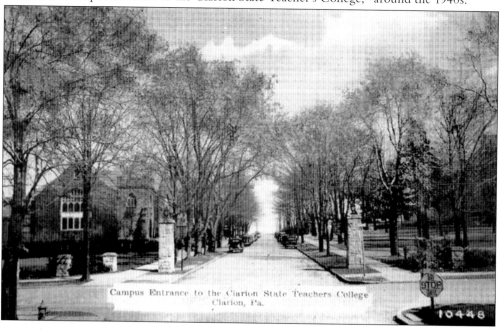

Campus Entrance to the Clarion State Teachers College
Clarion, Pa.

10448

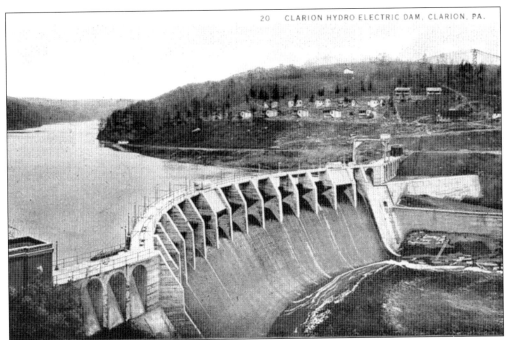

The Clarion River remained free flowing until 1924, when Piney Dam, near the borough of Clarion, was constructed. The dam flooded Piney Reservoir, stretching 10 miles upstream to the mouth of Mill Creek. The Clarion was an important rafting river through much of the 19th and early 20th centuries, with large quantities of timber floated to Pittsburgh and as far as New Orleans. Probably the last timber raft to float down the Clarion was piloted by James V. Cassatt. It left Clarington for Pittsburgh in December 1921 with 3,000 feet of lumber and a load of doors.

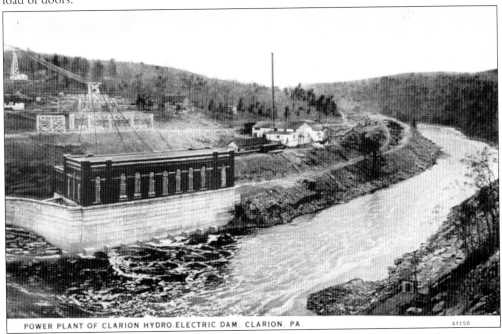

POWER PLANT OF CLARION HYDRO-ELECTRIC DAM, CLARION, PA. 61150

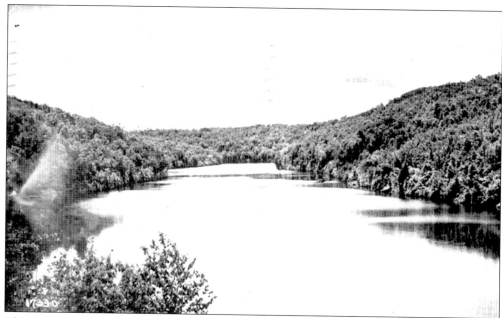

The character of the Clarion River changed dramatically when Piney Dam was completed. The swift flowing, shallow river with numerous riffles became a deep slack-water pool framed by steep slopes that meet the water's edge, as seen in the top card. The bottom card, "Scenic View of Clarion River, Facing South," shows one of the many boat docks that flanked Piney Reservoir.

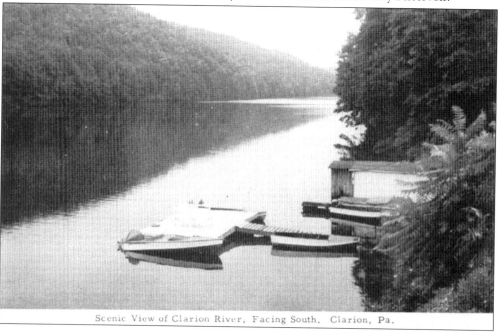

Scenic View of Clarion River, Facing South. Clarion, Pa.

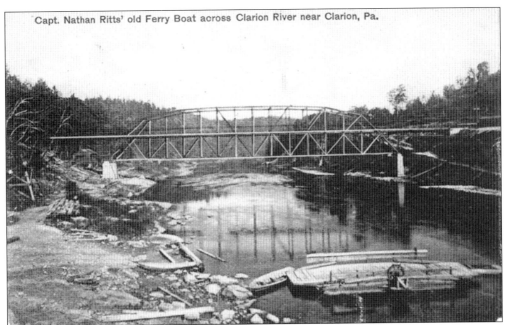

Capt. Nathan Ritts' old Ferry Boat across Clarion River near Clarion, Pa.

The top card, postmarked 1914, shows "Capt. Nathan Ritt's old Ferry Boat across Clarion River." The old "Pike" (i.e., Waterford and Susquehanna Turnpike) bridge appears in the background. Nathan Ritts was a well-known river pilot on the Clarion during the lumber rafting days. One old raftsman referred to Nathan and his brother Chris as "among the finest men I ever met." The bottom card shows the same bridge with a slack-water dam in the foreground and a raft in the center left.

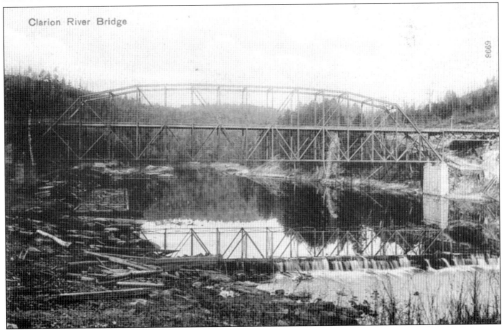

Clarion River Bridge

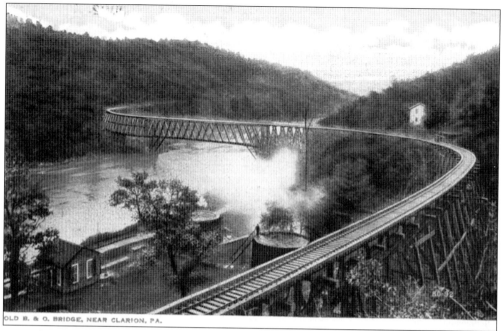

OLD B. & O. BRIDGE, NEAR CLARION, PA.

One of the marvels of the Clarion River was the old wooden Pittsburgh and Western Railroad (eventually the Baltimore and Ohio [B&O]) truss bridge near Clarion. Built in 1877, it was once the largest single truss trestle bridge in the world, spanning 200 feet. The bridge was abandoned by 1896 and then demolished in 1923, prior to closure of Piney Dam.

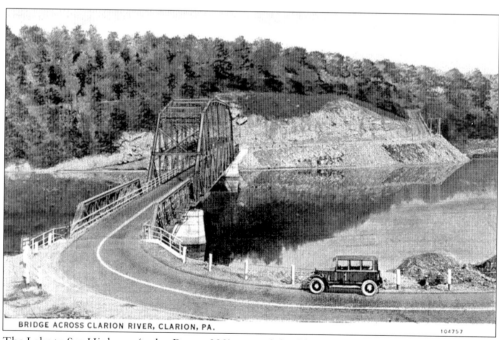

BRIDGE ACROSS CLARION RIVER, CLARION, PA.

The Lake to Sea Highway (today Route 322) crossed the Clarion River upstream of the old Pike and B&O bridges. Completed in 1920, it linked Atlantic City to Lake Erie. Like the Roosevelt Highway, the Lake to Sea Highway was largely assembled from other existing roadways.

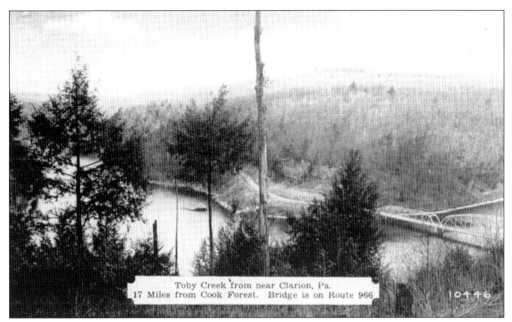

Toby Creek from near Clarion, Pa.
17 Miles from Cook Forest. Bridge is on Route 966

This card shows the junction of Toby Creek with the Clarion River from the overlook on the Lake to Sea Highway. The vegetation was cut away to enable the view. The Clarion County Centennial booklet of 1940 shows a similar view, also published by Carl and Don Studio, and notes that "hundreds of cars stop here daily to photograph and admire this beautiful view." Note the old Route 966 Bridge crossing the Clarion at the right.

TOBY DAM, CLARION, PA.

A. W. Corbett and Samuel Wilson manufactured lumber at the mouth of Toby Creek until 1882, when they sold their interests to Messrs. Carrier and Raine, who cut 10 million board feet of pine from the area. This card, postmarked 1922, shows a bracket dam, of which there were three, on Toby Creek. The dam was probably used by Corbett and Wilson and others to float lumber down to the Clarion River.

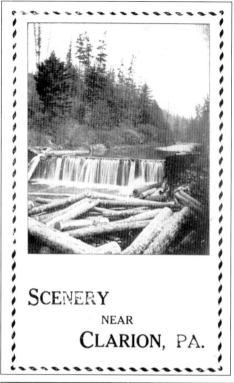

SCENERY

NEAR

CLARION, PA.

This view, "Scenery Near Clarion, PA," was probably taken in the vicinity of Mill Creek. It shows a small bracket dam with logs piled along the stream below the spillway. Bracket dams created ponds that logs were rolled into to await transport downstream. When all was ready, the bracket dam was opened and the logs shot down the stream. Often several bracket dams occurred on a stream, and the log drive grew in volume from dam to dam.

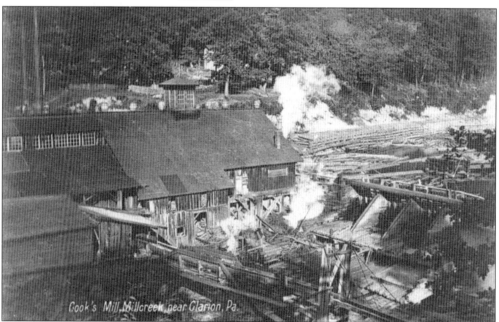

Cook's Mill, Millcreek, near Clarion, Pa.

This card shows a view of Cook's sawmill at the junction of Mill Creek and the Clarion River. The Cooks were a lumber family based upstream at Cooksburg. This mill was formerly owned by Marvin-Rulofson and cut about 60,000 board feet daily of pine, hemlock, and oak. The timber was floated down the Clarion in "rafts eight platforms long containing about 50,000 [board] feet."

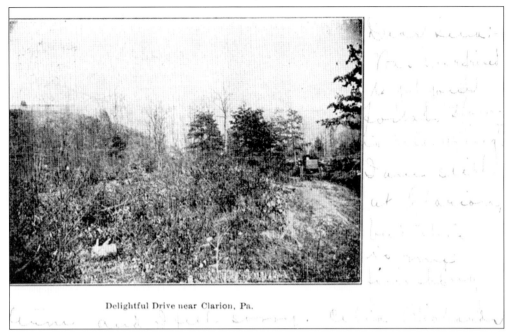

Delightful Drive near Clarion, Pa.

This card, postmarked 1907, is captioned "Delightful Drive near Clarion, Pa." What is most striking about this image is how cut-over the landscape appears. Decades of unchecked charcoal production and lumbering depleted the forest by the early 1900s. In 1887, historian A. J. Davis predicted that "seven years hence Clarion County shall be completely stripped of its pine and timber of value. Already there is a demand for stray lots of timber."

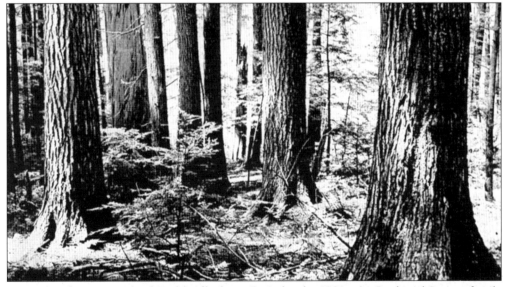

Few uncut forests remained in the Allegheny Basin by the 1920s. A. Cook and Sons, a family company, owned Cook Forest along the Clarion River, one of the last remnants of old growth white pine–eastern hemlock forest in the region. Anthony Wayne Cook, concerned that Cook Forest would be logged and lost, bought out the family company between 1910 and 1928. Ultimately, a fund-raising campaign spearheaded by the private Cook Forest Association and matched by state funds, was successful in preserving Cook Forest as a state park in 1928.

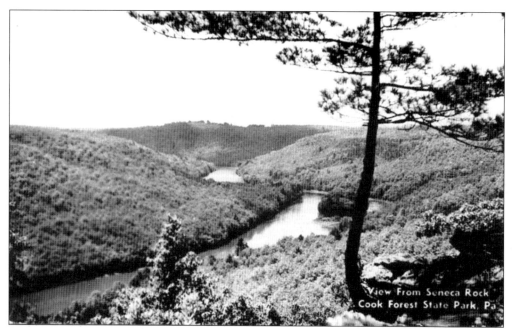

Seneca Point in Cook Forest, overlooking the Clarion River, is a prominent feature of the Clarion Valley. Native Americans once used indentations in the sandstone as grinding mills. Generations of tourists have admired the view, which was featured briefly in Cecile B. Demille's 1947 film epic, "Unconquered." These two cards, the top from the 1930s and the bottom postmarked 1939, show the view downstream toward Hemlock Island and Gravel Lick, once a thriving lumber center.

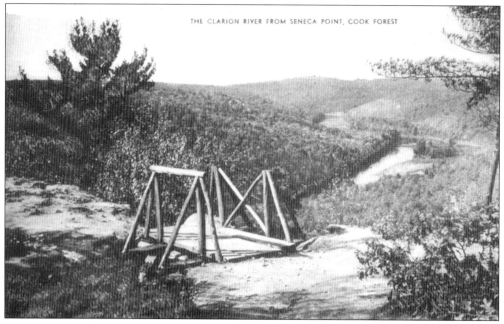

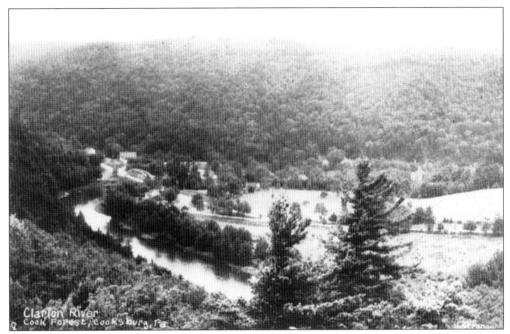

The top card, postmarked 1938, shows Cooksburg as seen from the Seneca Point fire tower. John Cook purchased land here in 1826 and built the first sawmill in the 1830s. Cooksburg was the center of the Cook Family's lumber empire, which included two sawmills that cut 2 million board feet of pine, hemlock, and oak in 1883. The white building just above the bridge is the Cook Homestead, built in 1870. The bottom card shows a mirror-calm Clarion River at Cooksburg.

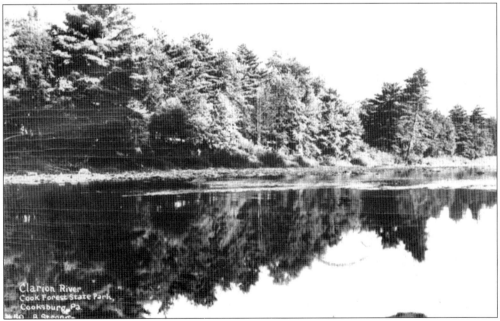

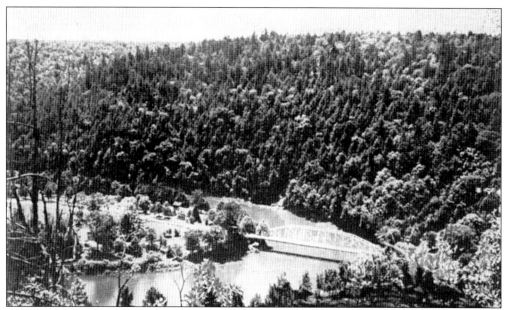

Four areas of old-growth occur in Cook Forest State Park. This view, around the 1930s, looking downstream from Cooksburg, shows the Seneca Point old-growth area on the slope above the old Route 36 Bridge. The forest here is dominated by ancient hemlock and white pine. Note the ragged look of the old-growth forest compared to the second-growth on the upper left of the card. This is due to the great height of the old-growth, "emergent" trees.

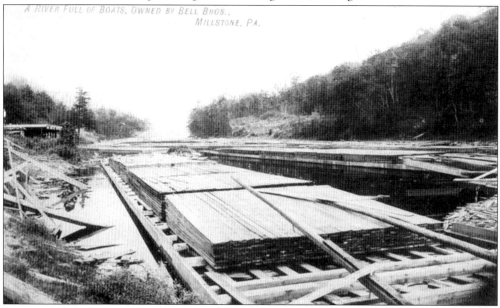

Timber rafting and boat building were important businesses on the Clarion River before the advent of railroads to the region. Rafting was largely a seasonal affair, done mainly during the spring high flows or "freshets" from March to April, or sometimes in late autumn or early winter when flows were high and ice was not a hazard. This view of the Clarion River near Millstone Run in Elk County, postmarked 1911, shows a line of lumber rafts owned by the Bell Brothers Lumber Company awaiting descent downriver.

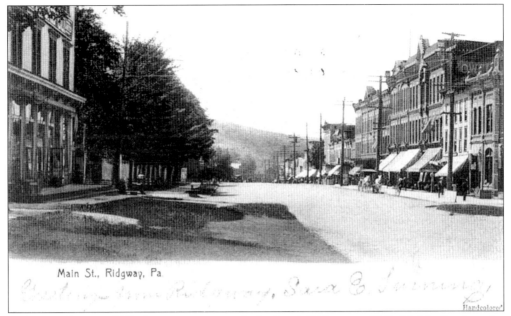

Main St., Ridgway, Pa.

Ridgway, the seat of Elk County, was named after Jacob Ridgway, a Philadelphia Quaker who purchased 80,000 acres in the region. Ridgway died in 1843 and was considered the wealthiest man in Pennsylvania at the time. In the early 1900s, the population was about 6,700. This view of "Main St., Ridgway, Pa.," postmarked 1906, was made in Germany and published by the Ross Drug Company.

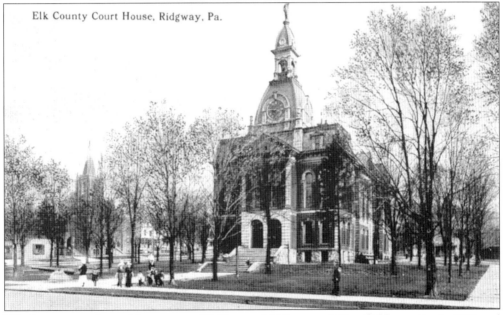

Elk County Court House, Ridgway, Pa.

Elk County was formed from parts of Jefferson, McKean, and Clearfield counties in 1843 and named for the elk that still roamed the region. The courthouse, commissioned in 1872, was built by J. H. Marston, the contractor who built the Warren County Courthouse that was designed by M. E. Beebe. The county commissioners wanted to copy the Warren County Courthouse on a smaller scale, which is why Marston was hired for the job.

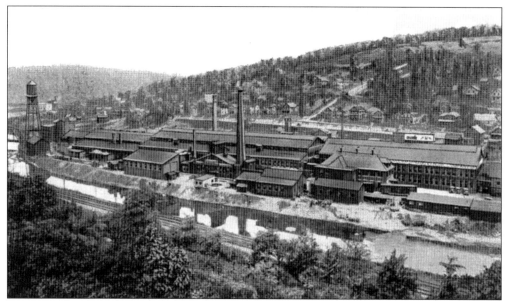

Ridgway was a manufacturing community including tanneries of the Elk Tanning Company and its Clarion Extract Works, the Ridgway Machine Works, the Russell Car and Snow Plow Works, the Dynamo and Engine Company, a machine shop and foundry, a brick works, and a planing mill. This card shows the plant of the Elliott Company in Ridgway, which in 1924 purchased the Dynamo and Engine Company. They produced turbines, compressors, and diesel engines, many of which were installed in U.S. warships.

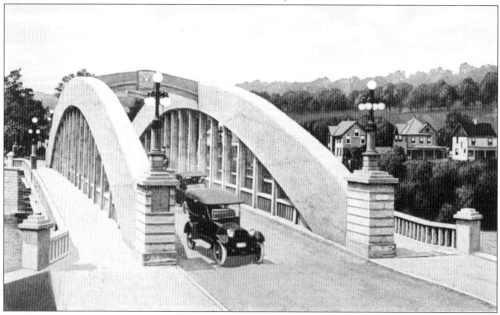

This view, postmarked 1918, is of the "Clarion River Bridge" at Ridgway. The message on this card was written in Swedish by Anna and sent to Mrs. Andy Anderson at Instanter. Many Swedes moved to the Northern Watershed in the late 1800s to work in lumbering, furniture making, and in tanneries. Instanter was a short-lived tannery community north of Ridgway on the Clarion River.

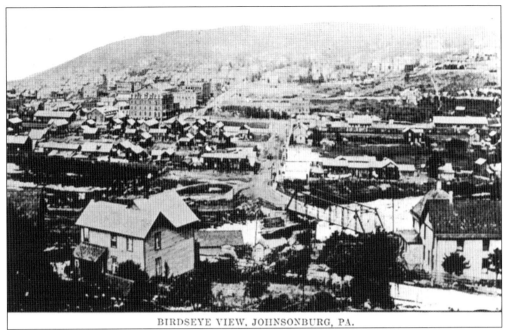

BIRDSEYE VIEW, JOHNSONBURG, PA.

Johnsonburg, located at the confluence of the East and West branches of the Clarion River, was the most industrialized town in the valley. Johnsonburg had a population of 4,200 in the early 1900s, and manufacturing was its livelihood. The New York and Pennsylvania Company pulp and paper mills and the Rolfe Tanning Company were the major employers. These two cards show views of Johnsonburg and the Clarion River, note the bridge in both views. The lower is postmarked 1910.

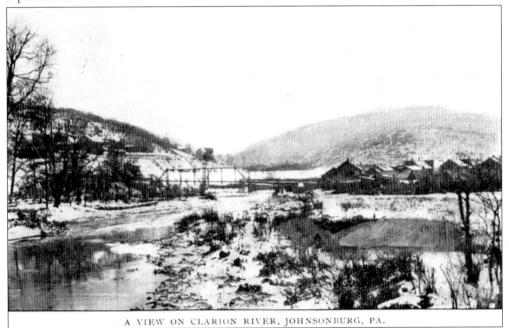

A VIEW ON CLARION RIVER, JOHNSONBURG, PA.

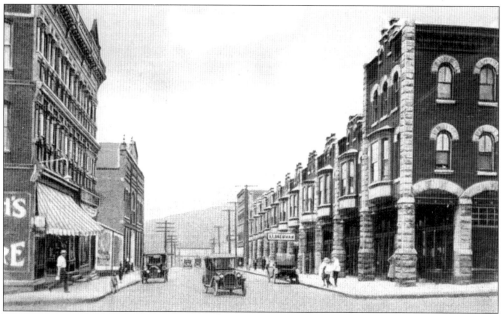

This view of "Market Street Looking North from Bridge Street," postmarked 1925, shows the business section of Johnsonburg. It appears more utilitarian than the centers of other similarly sized towns in the Allegheny's Northern Watershed. Note the row of identical brick buildings with the unusual columns of limestone on the right side of the street. The sender of the card writes "Just arrived here from Brockway. Am staying at the Anderson Hotel here."

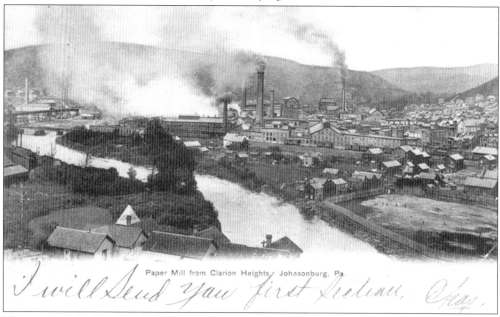

The New York and Pennsylvania Company pulp and paper mill and wood operations at Johnsonburg employed 1,450 workers in 1915. Wastes from these industries were dumped directly into the Clarion River, creating both nuisance and spectacle. A 1915 river survey noted, "the Clarion River at Johnsonburg presents an unusual feature, the west side of the river being fairly clear while the east side is badly stained by paper mill wastes."

Eight

THE MIDDLE ALLEGHENY
RIVER VALLEY

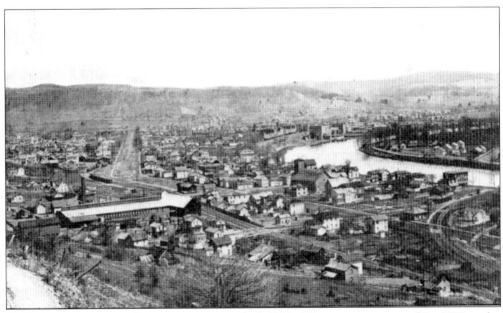

This bird's-eye view of Warren is postmarked 1908. Warren was surveyed in 1795 under the direction of Andrew Ellicott and Gen. William Irvine, commissioners appointed by the Commonwealth of Pennsylvania. Shortly thereafter, the Holland Land Company built a block storehouse, the first construction in the town, to supply surveyors and settlers. Early on, Warren, at the confluence of the Allegheny and Conewango Creek, became a focal point for the white pine lumber industry.

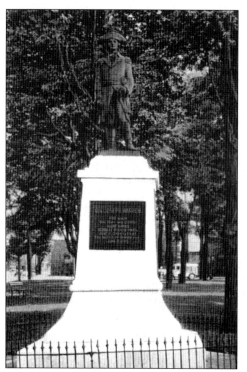

The town and county of Warren where named after Joseph Warren, a Revolutionary War major general who fell at the Battle of Bunker Hill in 1777. Warren was born in Roxbury, Massachusetts, in 1741 and graduated from Harvard with a degree in medicine in 1759. Warren was active in the Sons of Liberty and drafted the Suffolk Resolves, endorsed by the Continental Congress, which urged colonists to resist the British Crown.

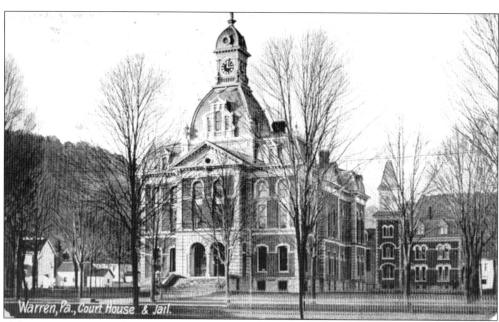

Warren County was formed in 1800 from part of Lycoming County but was not fully organized until 1819, when Warren became the county seat. The Warren County Courthouse, seen in this postcard postmarked 1911, was designed by architect M. E. Beebe and was built in 1877. It replaced the previous structure built in 1825. Unlike many courthouses in western Pennsylvania, the Warren County Courthouse is located in a residential area and not the business sector, a quirk of town development.

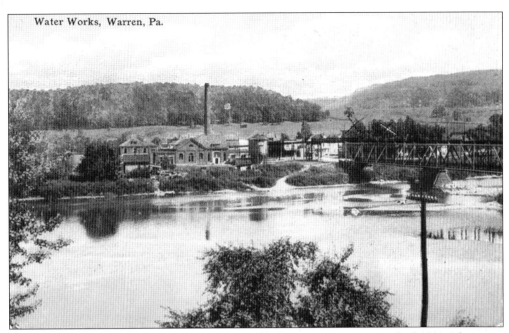

Water Works, Warren, Pa.

This view of the Warren water works on the Allegheny River is postmarked 1911. The water works included a pumping station and filtration plant, with a settling tank and mechanical filters that purified water taken from nearby Morrison Run. The water works was built at the foot of the Glade Run Bridge, shown in detail in the lower postcard. On the upper postcard Florence writes "Willie you ought to see the high bridge we crossed at Glade to go out at [to] Aunt Mary."

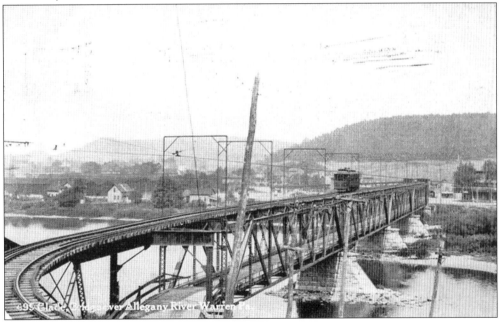

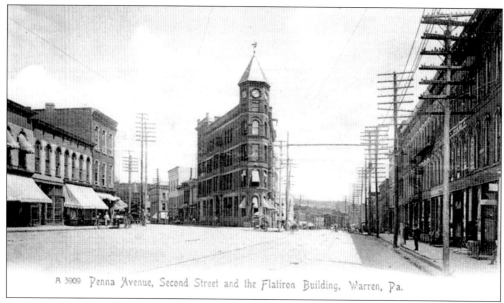

A 3909 Penna Avenue, Second Street and the Flatiron Building, Warren, Pa.

An icon of Warren's business district is the Flatiron Building at the junction of Pennsylvania Avenue and Second Street. "Flatiron" buildings were commonly built in many urban areas in the late 1880s where tightly angled street intersections negated construction of a more convention building. In the early 1900s, Warren had a population of around 11,000 and was a railroad and industrial hub with five oil refineries, an acid works, three furniture factories, a foundry, machine shops, boiler shops, and tank works.

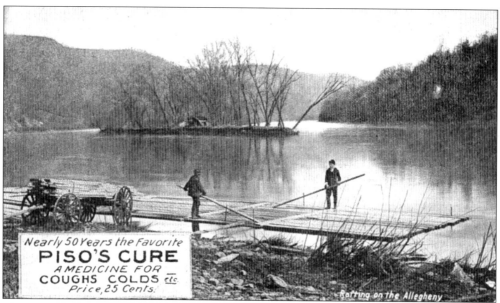

Nearly 50 Years the Favorite
PISO'S CURE
A MEDICINE FOR
COUGHS COLDS etc.
Price, 25 Cents.

Rafting on the Allegheny

This postcard, "Rafting on the Allegheny" promotes "Piso's Cure," a cough and cold medicine made in Warren. In 1863, E. T. Hazeltine secured the formula for this "medicine" and sold small quantities in his drugstore. Business was brisk, and by 1870, Hazeltine built a factory on Mead Island in the Allegheny River that could produce 1,000 bottles per hour. By 1880, a Piso's Cure branch office and laboratory was built near London, England.

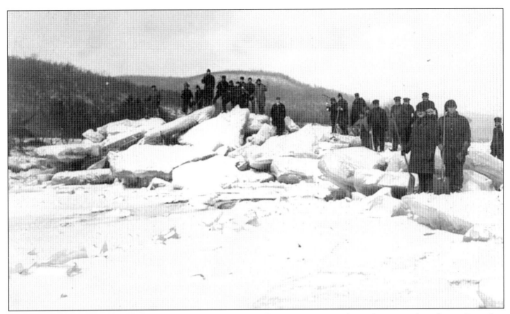

Ice "gorges" or dams were common on the Allegheny River in the winter and early spring. Ice dams form when large blocks of ice are lifted and transported by rising water and then deposited in the many bends and eddies of the river. Ice gorges can back up river flows, causing local flooding. This winter scene from the early 1900s on the Allegheny River near Warren shows an army of saw- and shovel-bearing men preparing to loosen an ice dam to prevent flooding of the town.

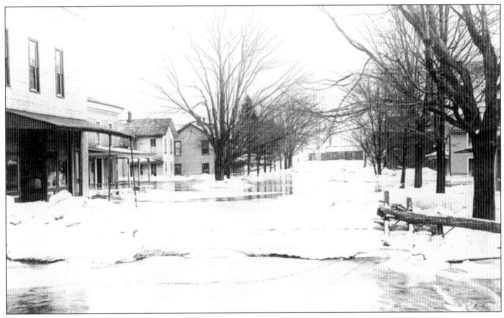

Despite best efforts to break them up, including use of dynamite, flooding due to ice gorges was not an uncommon event along the Allegheny River. This flood in Warren in the early 1900s covered streets and yards and flooded the basements and lower floors of homes and stores along the river.

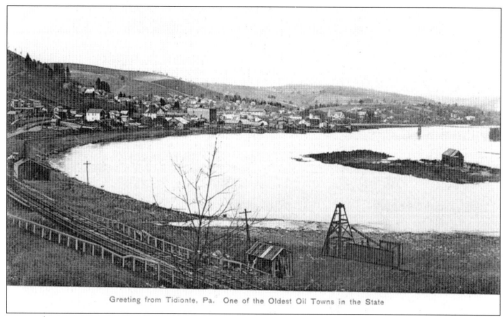

Greeting from Tidionte, Pa. One of the Oldest Oil Towns in the State

Tidioute, Warren County, was a small river and lumber town until John L. Grandin sunk his first oil well in 1859. Speculators, mostly from Warren and Titusville, quickly crowded into town. By August 1860, *The Warren Mail* reported, "In the vicinity of Tidioute . . . are . . . about 50 wells, with others beginning every day . . . every tavern has three times as many guests as it can comfortably lodge." Note the oil shed on the river island in the foreground of the top card.

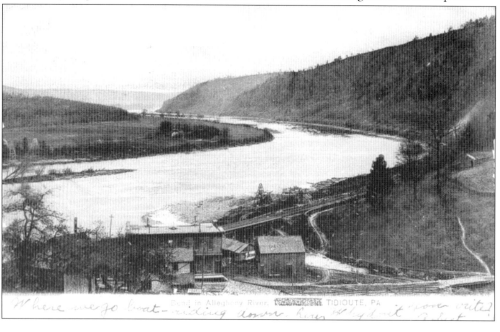

Bend in Allegheny River. TIDIOUTE, PA

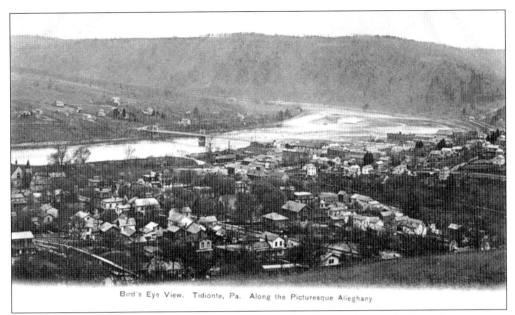

Bird's Eye View. Tidionte, Pa. Along the Picturesque Alleghany

Here is Tidioute as it appeared in the early 1900s in a bird's-eye view card. Note that the name of the town on this card, Tidionte, is spelled wrong. Tidioute is Native American in origin but its meaning is unclear. Tidioute may mean "see far," "straight water," or "cluster of islands." Tidioute has also been called the "burying ground" because of the legend that a famed Native American was buried here.

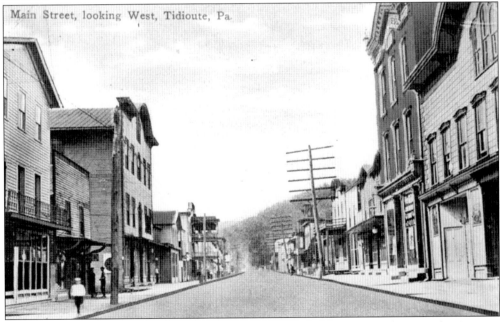

Main Street, looking West, Tidioute, Pa.

Main Street, Tidioute, is shown as it appeared in the early 1900s. The population at the time was about 1,300, and the chief industries included machine shops and cutlery, chair, furniture, and hub works. The Tidioute Cutlery Company was founded here in 1898, manufacturing knives and razors until it was taken over by Union Cutlery in 1902. Union Cutlery would become Ka-Bar Cutlery in 1952, famous for its Ka-Bar survival knife.

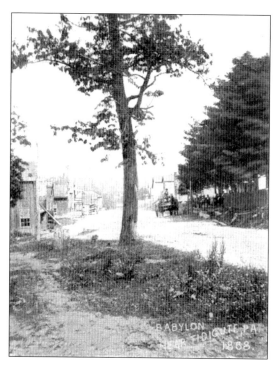

Babylon, located west of Tidioute on the Warren-Franklin Turnpike, was sometimes called the "Red-light District of the Oil Region," as six of its first eight businesses were "sporting houses" or brothels. Brothel keeper Ben Hogan, the self-proclaimed "Wickedest Man in the World," established a dance hall and "gymnasium" in Babylon in 1866. Hogan made $300 a day at Babylon. This view of Babylon in 1868, postmarked 1909, was published by Henry Ewald.

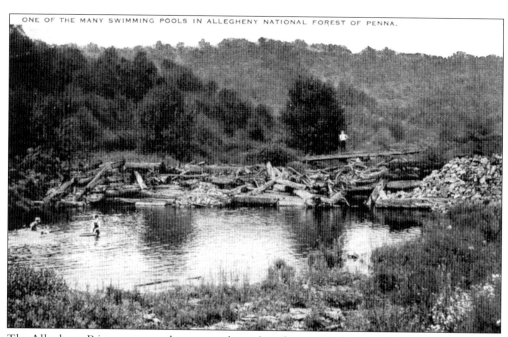

The Allegheny River serves as the western boundary for much of the Allegheny National Forest (ANF). Established in 1923, the ANF comprises over 500,000 acres, much of which was heavily cut-over for lumber, tan bark, and chemical wood. This card, postmarked 1930, shows two people swimming in a pond created by what appears to be a bracket dam, part of the forest's logging heritage.

The lands comprising the Allegheny National Forest were so heavily cut-over that the forest was commonly called the "Allegheny brush pile" shortly after its establishment. One of the problems associated with the aftermath of excessive logging was forest fire, some covering thousands of acres at a time. This card shows one of the many fire towers established in the forest and adjacent lands in the 1920s and 1930s.

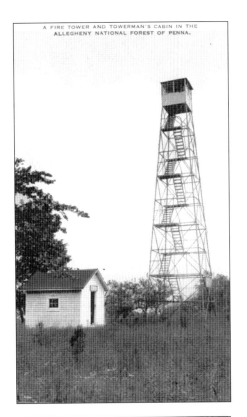

A FIRE TOWER AND TOWERMAN'S CABIN IN THE ALLEGHENY NATIONAL FOREST OF PENNA.

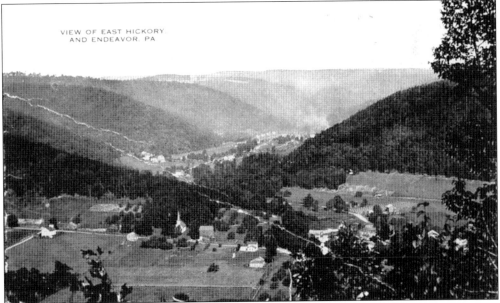

VIEW OF EAST HICKORY AND ENDEAVOR. PA

East Hickory Creek joins the Allegheny River about eight miles below Tidioute. Just north of here, in 1769, David Zeisberger, a Moravian missionary, established a mission called Lawunakhannek, which means "at the meeting place of the streams," to convert Native Americans to Christianity. This part of the Allegheny, with its many river islands and fertile bottoms, was home to Delaware Indians displaced from the east. Lawunakhannek was abandoned in 1770.

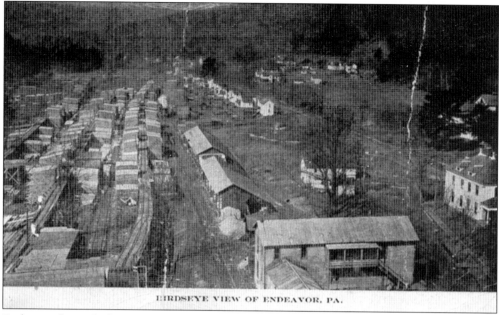

BIRDSEYE VIEW OF ENDEAVOR, PA.

Endeavor, formerly Stowtown, was the hub of the Wheeler and Dusenbury Lumber Company, organized in 1867. Two mills were located at Endeavor: an upper or "pine" mill and a lower or "hemlock" mill. This view is from the lower mill looking down the valley toward East Hickory. Note the large quantities of stacked boards awaiting transport at the left of the image. The company's office is the white building at the far right of the image.

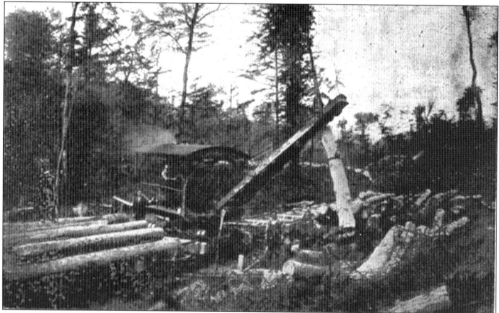

From 1887 to 1938, Wheeler and Dusenbury operated one of the most extensive railroad logging networks in the Allegheny Basin, the Hickory Valley Railroad, spanning large portions of Forest and Warren counties. The Hickory Valley Railroad connected with the Pennsylvania Railroad at West Hickory, crossing the Allegheny River on a 640-foot wooden truss bridge. This card shows a steam-powered American Log Loader readying logs for rail transport to Endeavor.

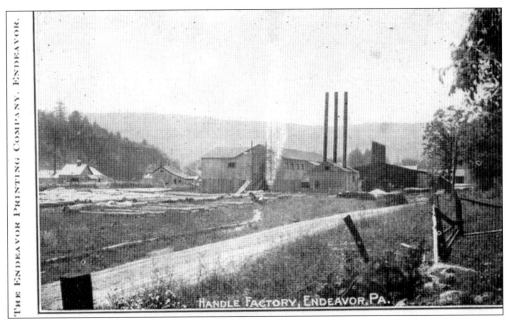

HANDLE FACTORY, ENDEAVOR, PA.

The Wheeler and Dusenbury operations at Endeavor also included a handle factory, as seen in this card postmarked 1910. The handle factory made use of wood too small for boards or used species which had little other value. The dirt road in this image is the current State Route 666. Wheeler and Dusenbury closed their mills in 1934, closed the Hickory Valley Railroad in 1938, and sold the mill site to the Endeavor Lumber Company in 1941. Endeavor Lumber continues operations today.

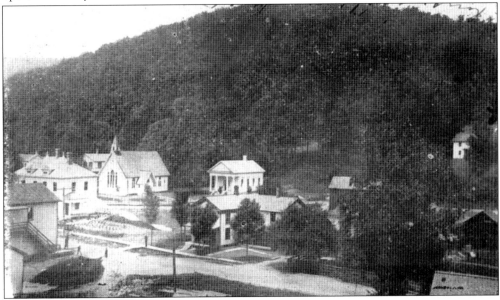

In 1876, Nelson Wheeler married Rachel Ann Smith, a prominent, well-educated lady he met during a rafting trip to Cincinnati. The Wheelers took an interest in their community, building both a small Presbyterian church and a "kindergarten hall" in 1897. This view of Endeavor, postmarked 1906, shows the Presbyterian church in the left-center of the image opposite the Wheeler and Dusenbury office and the kindergarten hall in the center of the image.

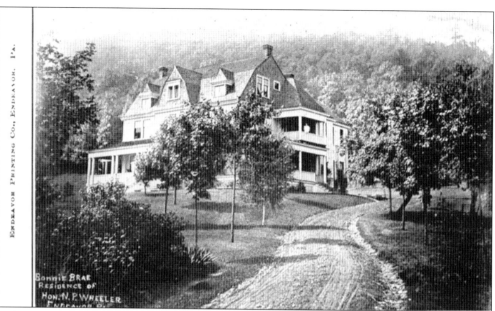

Nelson P. Wheeler moved to the Allegheny Valley in 1865 from Portville, New York, to join his father, William, in the lumber business. In 1871, he took charge of Wheeler and Dusenbury's holdings along East Hickory Creek. Wheeler served two terms in Congress from 1908 to 1911, retired to California, and died in 1920. Bonnie Brae, built on the hill overlooking Endeavor, was the residence of Rachel and Nelson Wheeler.

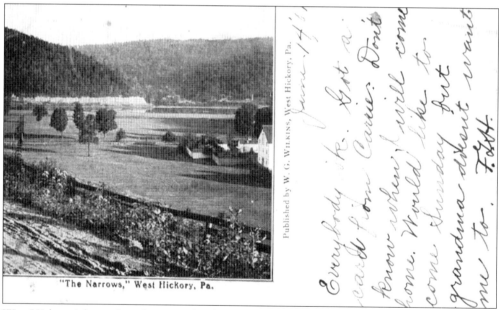

"The Narrows," West Hickory, Pa.

West Hickory is located on the west side of the Allegheny River about two miles downstream from East Hickory. The Richland Tract, given to Cornplanter in 1791 by the State of Pennsylvania, was located nearby, as was the Delaware town(s) of Goshgoshing, visited by David Zeisberger in 1767. This card, postmarked 1907, shows "The Narrows" at West Hickory. "Narrows" refers to the slopes at the back of the image that tightly hem the river and restrict travel.

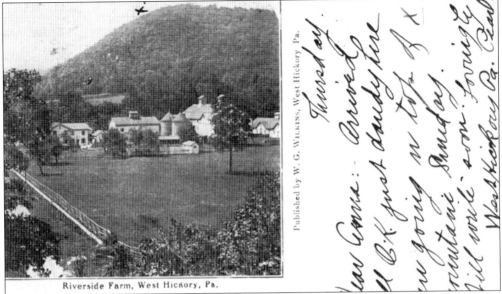

Published by W. G. WILKINS, West Hickory, Pa.

Riverside Farm, West Hickory, Pa.

The "flats" at West Hickory are among the best developed on the Allegheny River south of Kinzua. These fertile flats are especially valued for agriculture, as evidenced by the prosperous farm depicted on this card, "Riverside Farm, West Hickory, Pa.," postmarked 1907. Zeisberger's Goshgoshing, meaning "place of the hogs," probably in reference to the hogback hills of the area, consisted of two or three "towns" that shifted along the flats from West Hickory to Tionesta, a fluid pattern of settlement.

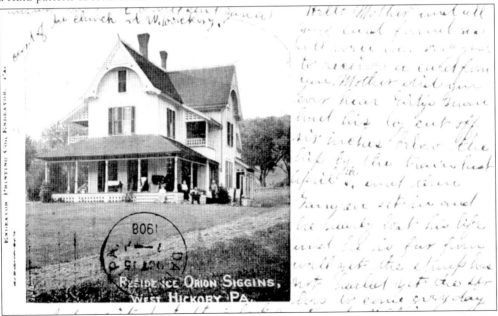

RESIDENCE ORION SIGGINS, WEST HICKORY, PA.

An icon of West Hickory is the Orion Siggins House, shown in this card postmarked 1908. Irish immigrant George Siggins settled on the West Hickory Flats in 1801. His choice of land was praised in a local history: "No better body of land lies on the river between . . . the mouth of Brokenstraw, and Kittanning. It is so high that it is not subject to overflow by the river, and raft freshets do not destroy the fences or wash off the soil from the plowed fields."

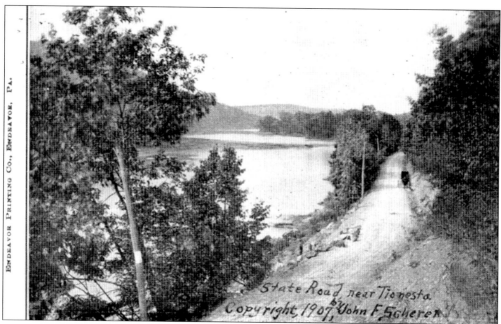

State Road near Tionesta.
Copyright 1907, John F. Scherer

This card "State Road near Tionesta," around 1907, shows the predecessor of today's Route 62 on the east bank of the Allegheny River looking north. Note the boulders piled on the left side of the road just below the center of the image. There the road bank appears to be unstable, with the rock placed as a warning to steer clear, perhaps the reason the oncoming buggy is hugging the road's right side.

This image shows the Pennsylvania Railroad track heading north from Tionesta on the west bank of the Allegheny River, around 1906. The line hugged the river closely at this point and was susceptible to flooding. The Pennsylvania Railroad was the only freight and passenger line through the area in the early 1900s. The other rail lines—the Hickory Valley and Tionesta Valley railroads—were lumber roads.

The Allegheny River around Tionesta, with its many river islands and scenic fringing hills, has always been considered a scenic delight. On this card showing the Allegheny River near Tionesta, the sender writes "Scenery here is plenty neat, postcard not a true indication."

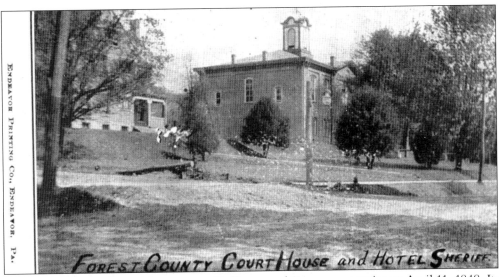

Forest County was formed from parts of Jefferson and Venango counties on April 11, 1848. Its area was increased with the addition of five townships from Warren and Venango counties on October 31, 1866. The Forest County Courthouse, built 1870, was the first brick building in the county. The bell tower was removed at a later date and is currently displayed on the lawn. "Hotel Sheriff" in the card's caption refers to the jail and sheriff's house, built 1895, in the upper left of the image.

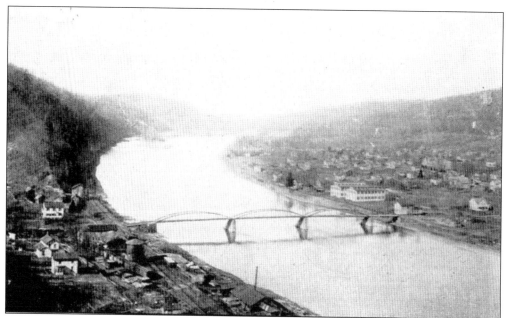

Tionesta, the seat of Forest County, lies at the junction of the Allegheny River and Tionesta Creek. Tionesta may be a corruption of the Native American "Tyonesiyo," which means "there it has fine banks." In the early 1900s, Tionesta had a population of 850. Its industries consisted of a casket hardware plant, a tank factory, a planning mill, and a gristmill. The top image, postmarked 1908, shows the "North End" of Tionesta. The lower image, postmarked 1910, shows a view of Tionesta looking toward the southeast.

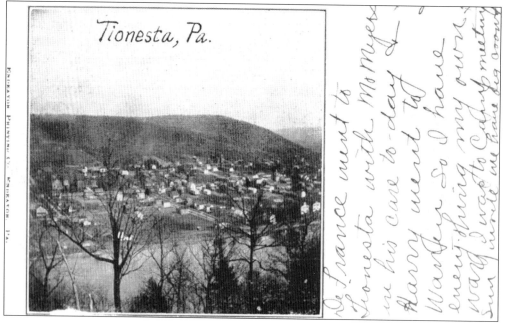

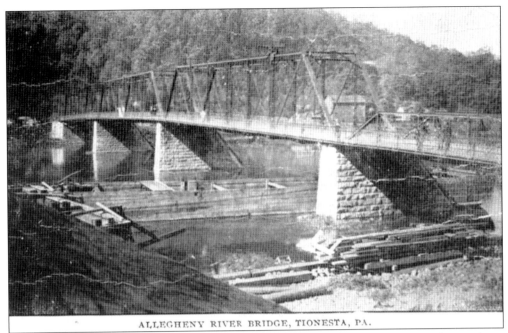

ALLEGHENY RIVER BRIDGE, TIONESTA, PA.

The top view of the "Allegheny River Bridge, Tionesta, Pa.," postmarked 1909, shows a large lumber raft under the bridge and boards onshore ready to be loaded. Note the length of the raft, which extends beyond the bridge abutment on the center right of the image and beyond view on the left. By this date, rafting was becoming a vestige of a passing era as large white pine was depleted and railroads took over the burden of transport. The bottom view, postmarked 1910, shows the same bridge with a view toward the town.

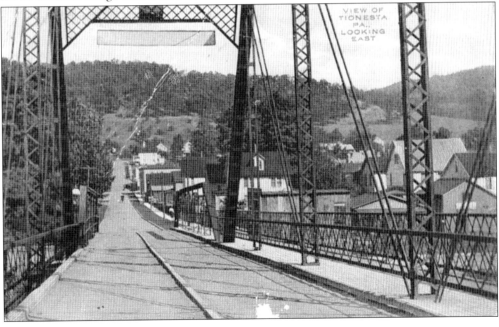

These cards show two different views of Elm Street, the main road through Tionesta. The top image, a card published by the Forest Press in 1994, shows part of the business section of the town in 1880. The lower image, postmarked 1908, shows an unpaved Elm Street, covered with carriage tracks, in a view looking south.

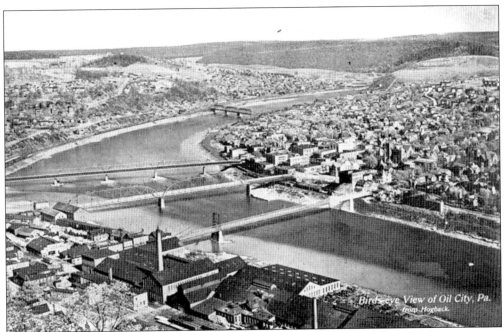

The top card "Bird's-eye of View of Oil City, Pa.," postmarked 1909, was taken from Hogback Hill on the city's North Side. In the early 1900s, Oil City had a population of about 15,000. Oil City was the oil refining hub of the Middle Allegheny Valley, with four large refineries——the Crystal, the Continental, the Independent, and the Penn—on the Allegheny and nearby Oil Creek. Note the loss of bridges in the lower photograph, around the 1930s.

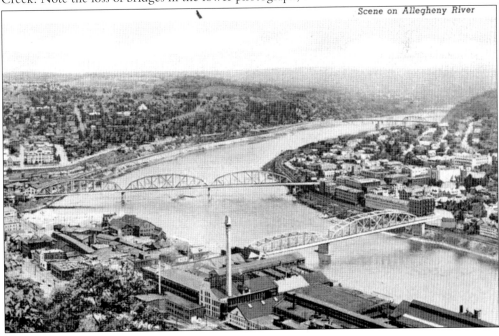

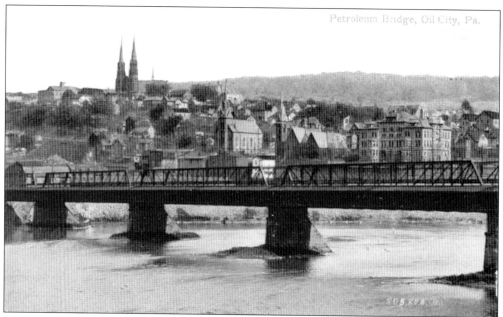

One of the three tracts of land given to Cornplanter in 1791 was called "the Gift," which encompasses the current business district of Oil City. Cornplanter sold this tract to William Connelly and William Kinnear in 1818 for $2,120. Due to untimely payment, Cornplanter felt cheated on the deal and never forgot the loss of the tract. This card shows the Petroleum Street Bridge, spanning the Allegheny just upstream from Oil Creek, part of "the Gift."

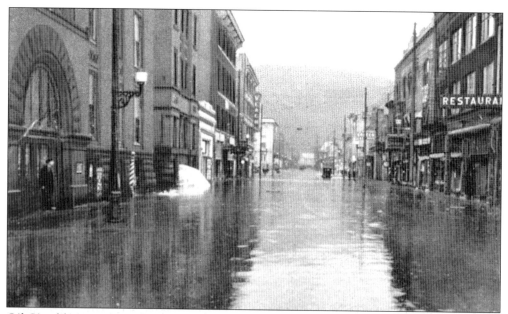

Oil City, like most towns built on the Allegheny River floodplain, had problems with periodic floods. This card shows Seneca Street, on Oil City's North Side, during the spring flood of 1926. The National Transit Building, with the man standing in the doorway, appears on the left side of the image. In the 1880s, National Transit, a subsidiary of Standard Oil, controlled over 10,000 miles of pipelines and had tank capacity for 55 million gallons of crude oil.

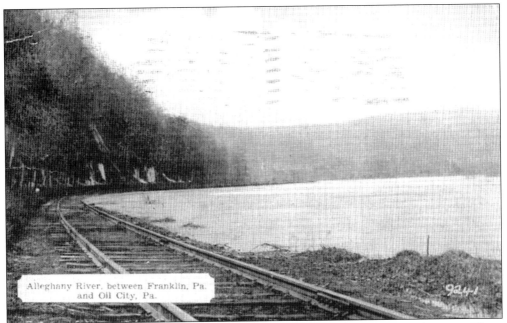

Alleghany River, between Franklin, Pa.
and Oil City, Pa.

Indicative of its oil hub status, Oil City was well served by rail lines in the early 1900s. Three lines paralleled the Allegheny River: the Erie and Lake Shore and Michigan Southern on the west side, and the Allegheny Division of the Pennsylvania Railroad on the east side. These two cards, postmarked 1945 and 1913 respectively, show the Pennsylvania Railroad line heading south to Franklin. The sender of the top card writes " . . . pretty well keyed up for fishing after seeing all this good fishing water."

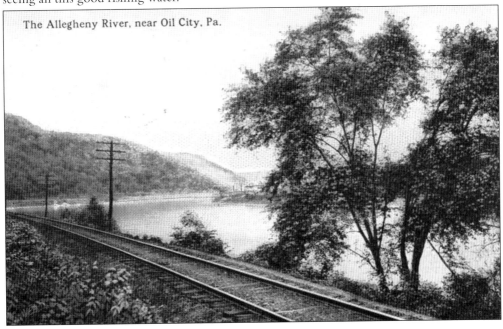

The Allegheny River, near Oil City, Pa.

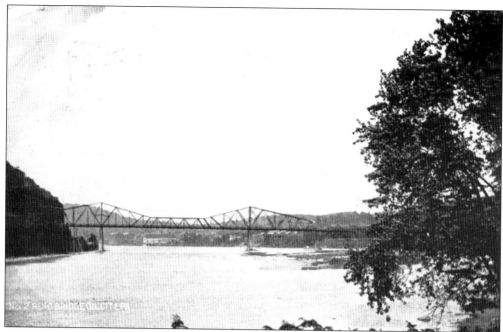

Reno, halfway between Oil City and Franklin, was a planned community of the Reno Oil Company, named for Civil War Gen. Jesse Reno. Reno was the dream of Charles Vernon Culver, a banker and promoter. Central to his vision was completion of the Reno, Oil Creek, and Pithole Railroad, which would link Reno to other oil production hotspots. Culver's bank failed in 1866, the railway was never completed, and his dream was never realized. The views, postmarked 1909 (top) and 1913 (bottom), show the No. 2 Bridge at Reno.

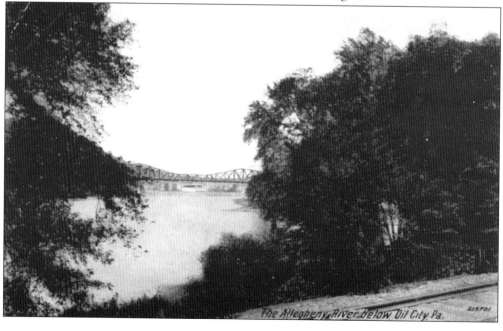

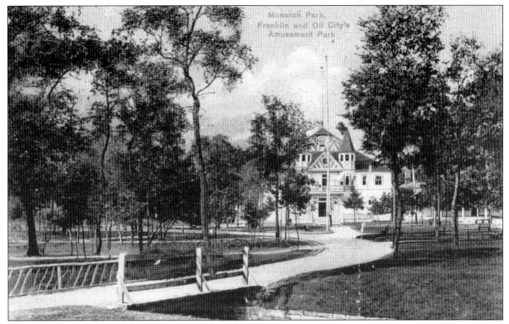

Amusement parks were in vogue in the early 1900s. In the oil region of the Middle Allegheny River Valley, the place to be on a weekend was Monarch Park, halfway between Oil City and Franklin. Owned by the Citizen's Traction Company, Monarch Park had gardens, a dance hall, a bowling alley, and a roller coaster. The top card, postmarked 1910, shows the well-groomed grounds. The bottom card, postmarked 1914, shows the "Children's Play Grounds."

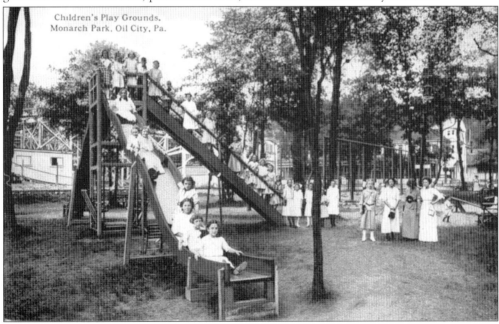

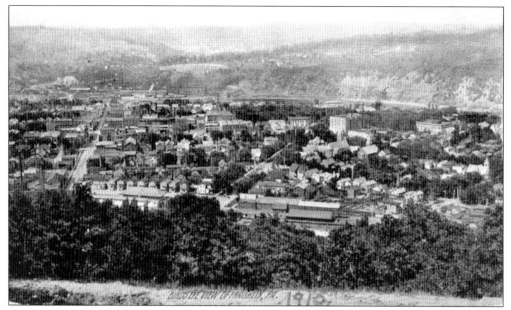

Franklin, the seat of Venango County, was a city of 10,000 in the early 1900s, buoyed by the growth of the oil industry. In 1864, actor John Wilkes Booth moved to Franklin and invested in the Dramatic Oil Company, which produced only dry wells. He left Franklin on September 28, 1864, for Canada and New York. On April 14, 1864, Booth resurfaced at the Ford Theater in Washington, D.C., and assassinated Pres. Abraham Lincoln.

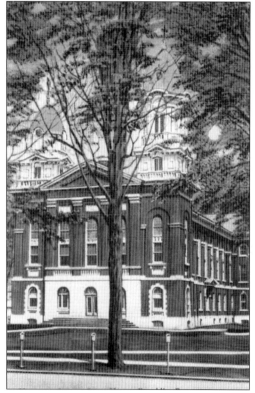

Venango County was formed from parts of Allegheny and Lycoming counties on March 12, 1800. The Venango County Courthouse, with its distinctive twin towers, was built on brick and sandstone in 1868. It had two predecessors: a stone courthouse built in 1811 and one of brick built in 1848. The county commissioners originally wished to fireproof the 1848 structure but found it more economical to build a new one.

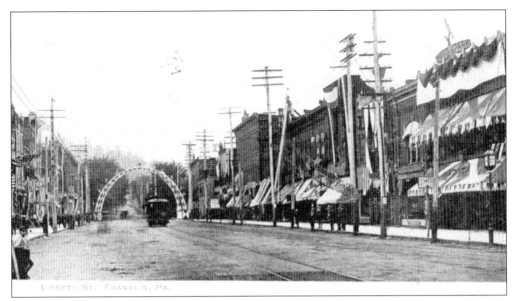

Victorian Franklin was largely built by high-grade oil. Franklin crude was heavier than that of the oil fields to the north. With minimum refining, it became an outstanding lubricant, commanding high prices. This view of a prosperous Liberty Street, Franklin's commercial center, is from a postcard published by E. C. Kropp and postmarked 1906. The trolley line seen in this image continued for eight miles up the Allegheny River, connecting Franklin with Oil City.

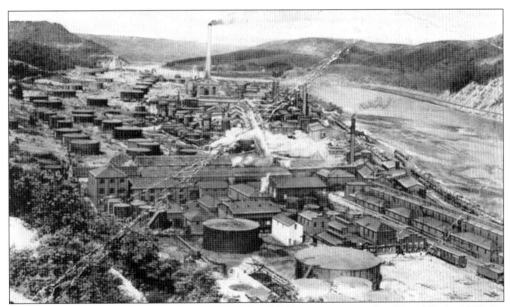

The Eclipse Oil Refinery was established on the Allegheny River north of Franklin in 1872. By 1877, the refinery was "the largest of its kind in the world." Built by local producers to compete with J. D. Rockefeller's Standard Oil, inept management sent the refinery into bankruptcy within four years. Ironically, Standard Oil bought Eclipse and turned it into a productive enterprise. In 1904, the refinery covered 125 acres, processed 10,000 barrels of crude daily, and produced 130 different commercial petroleum products.

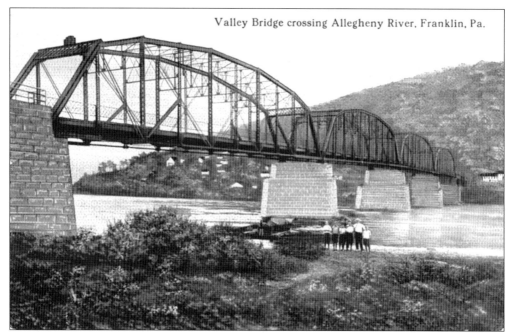

Valley Bridge crossing Allegheny River, Franklin, Pa.

The Valley Bridge crossed the Allegheny River at Franklin, just below the confluence of French Creek. Built in the early 1900s, the Valley Bridge was a truss bridge with four main spans. It was replaced in 1986. A suspension bridge, which burned in 1870, preceded the Valley Bridge. The fire that destroyed it burned the suspension cables and the bridge collapsed, causing several deaths.

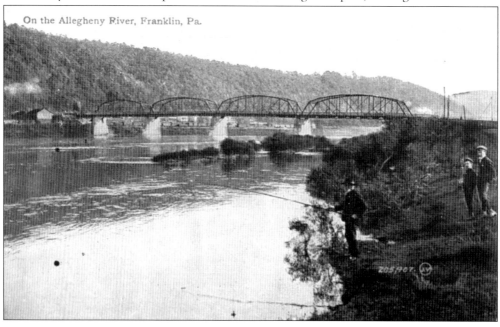

On the Allegheny River, Franklin, Pa.

Copyright 1905 by the Rotograph Co.
5450 Scene on the Allegheny, Franklin, Pa.

Like its counterpart to the north at West Hickory, the narrows along the Allegheny River at Franklin was a conspicuous feature of the landscape. The card above, postmarked 1906, shows the Allegheny River looking north toward Franklin, with the narrows on the east side of the river. The card below, postmarked 1910 and captioned "Ice at the Narrows," shows the dirt road that later will become the Lake to Sea Highway.

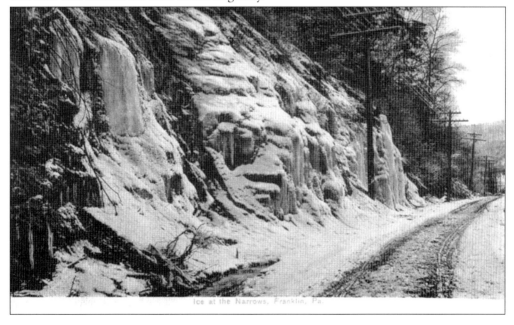

Ice at the Narrows, Franklin, Pa.

117

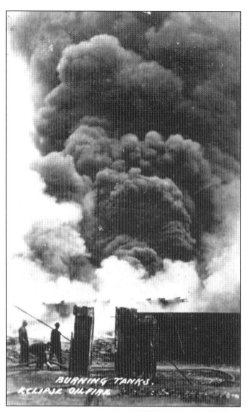

Fires were not an unusual event at the many refineries that lined the Allegheny River between Oil City and Franklin. Fires ignited by accident or lightning strike were readily fueled by the abundant gas and oil. The card on the left shows oil tanks burning at the Eclipse Refinery during the October 11, 1911 fire. The bottom card, captioned "The Wrecked Building, Eclipse Oil Refinery Fire, Oct. 11-1911," was published by F. W. Kirby and was printed in the United States. The Eclipse Refinery closed in 1927.

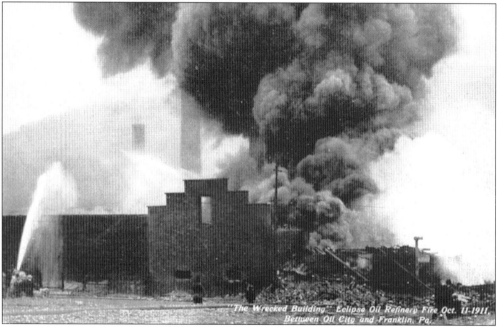

The flow of productive oil wells sometimes slowed or stopped due to the plugging of well shafts with paraffin and other materials. One solution was to "shoot the well," initially with gunpowder and later with nitroglycerine, to remove obstructions. Well shooting with nitroglycerine was a spectacle—and it was dangerous. During the early oil years, Venango County alone had 31 deaths attributed to well shooting. This card, "Shooting an Oil Well, near Franklin, Pa," shows a well shooter and his rig in action.

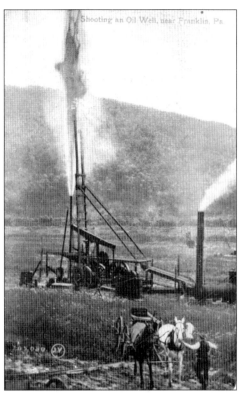

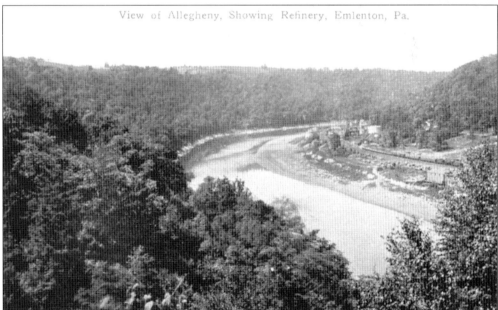

The Emlenton Refining Company, founded in 1895, would play a key role in the development of the Quaker State Company. In 1919, the Franklin Automobile Company of Syracuse, New York, was searching for a lubricant to serve its air-cooled, high temperature engines. A new motor oil, developed by the Phinny Brothers of Oil City, met the need. It was manufactured at Emlenton Refining under the Quaker State Brand, which would give rise to the Quaker State Company.

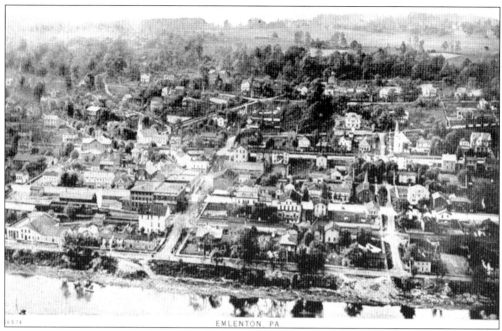

Emlenton, Venango County, is located about 30 miles downstream of Franklin on the Allegheny River. Emlenton's population in the early 1900s was about 1,300. At the time, its major industries were the Emlenton Oil Refinery, a woolen mill, and several small machine shops. Joseph M. Fox owned much of the land around the town, naming it Emlenton after his wife's maiden name, Emlen.

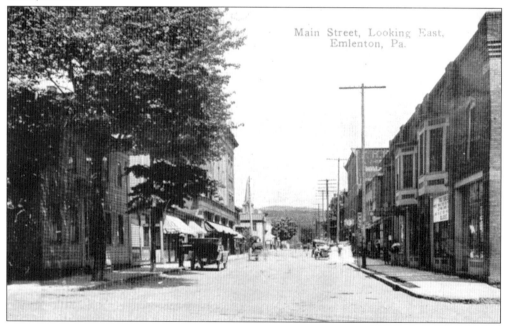

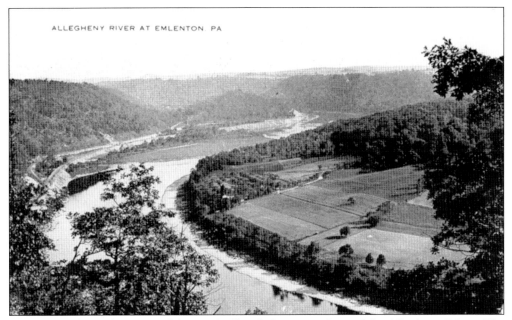

Emlenton is located on one of the scenic "bends," or meanders, of the Allegheny River. The 1885 Allegheny River Pilot, a guide to navigating the river by boat and raft, notes that floating past Emlenton will require care "to keep from rubbing the rocks along the right shore." It also notes that Emlenton "has arrived to the dignity of quite a commercial place. Large quantities of grain are annually shipped from this to foreign ports."

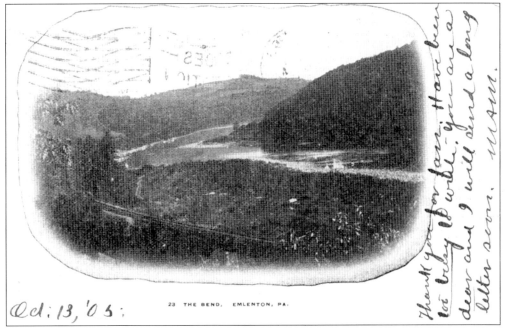

23 THE BEND, EMLENTON, PA.

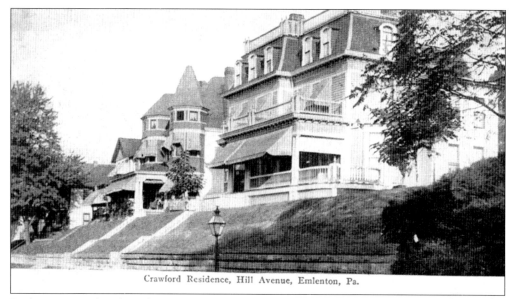

Crawford Residence, Hill Avenue, Emlenton, Pa.

Emlenton was already a thriving river town when oil became the mainstay of its economy. The Crawford family of Emlenton was prominent in the region's oil industry. The card above, postmarked 1907, shows two of the family's Victorian residences, icons of Hill Street that stand today. H. J. Crawford, a principal in the Emlenton Refining Company, built the Queen Anne house on the left in 1903. Ebenezer Crawford built the Second Empire house on the right.

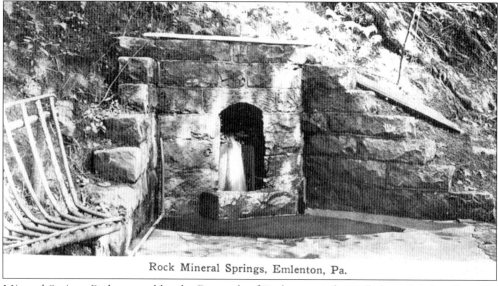

Rock Mineral Springs, Emlenton, Pa.

Mineral Springs Park, owned by the Borough of Emlenton, is located along Ritchey Run. In 1867, Ebenezer Crawford drilled the Ritchey Well, which is still in production, to a depth of 861 feet. In 1996, the Ritchey heirs donated the well to the borough to preserve the well's history and pumping tradition. This card above, postmarked 1908, shows the "Rock Mineral Springs" for which the park is named.

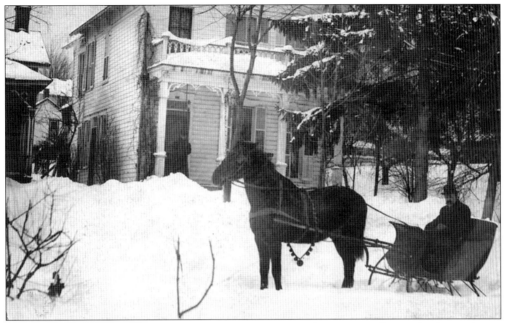

This postcard, postmarked 1910, shows a winter scene in Emlenton, complete with a horse-drawn sleigh. Note the set of bells on the horse's mid-section. The snow on the road has been compacted by travel, but notice its depth on the roofs of the houses.

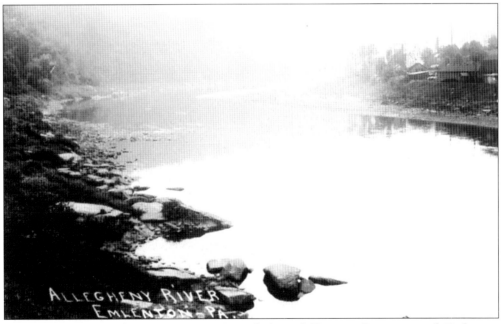

The Allegheny River changes in nature as it winds through Venango County towards Emlenton. The valley is narrow and constrained by steep slopes. Flats or bottomlands are rare, except at the mouths of major tributaries. Here the river slows and deepens with pools that may reach 14 feet in depth and a mile in length. The view of the Allegheny River at Emlenton, looking upstream, shows a placid river with a mirror-like luster to the water's surface.

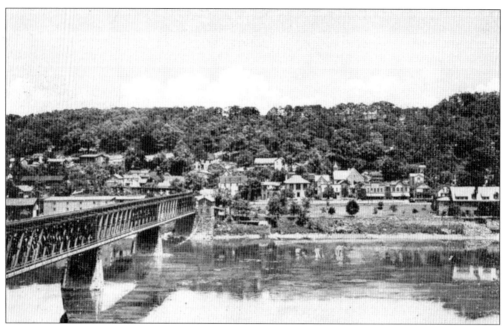

Foxburg, four miles below Emlenton, was established in 1847. Foxburg was never an industrial town but instead relied on supporting the oil industry, and on the B&O and Pennsylvania railroads for livelihood. This view of the town shows the historic double-decker B&O railroad bridge over the Allegheny. Trains rode on the upper deck; buggies and cars on the lower one.

2 "The Inn", Foxburg, Pa.

William Logan Fox, son of Joseph Fox, used his energy and capital to build Foxburg. Through his efforts, a school, a hotel, and residences were built, streets were graded, and a railroad was built that linked Foxburg to the surrounding region. Foxburg became an important staging area for the Clarion oil fields. The Inn at Foxburg on the Allegheny River, shown in this card postmarked 1908, was an icon of the community.

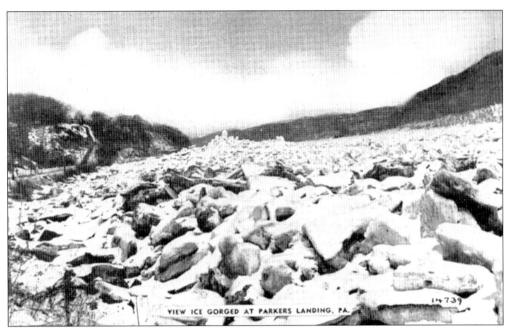

VIEW ICE GORGED AT PARKERS LANDING, PA.

Ice gorges were common during the winter on the Allegheny River at Parker's Landing, often starting as jams near the islands at the confluence of the Clarion River. The top Silvercraft card, around the 1940s, is a view of the river looking north from the bridge at Parker. The caption on the lower card, of the same series and era as the top card, notes that the "ice jam . . . threatened to wipe out homes and business places along River Avenue."

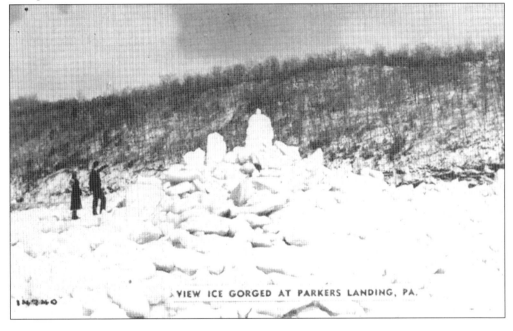

VIEW ICE GORGED AT PARKERS LANDING, PA.

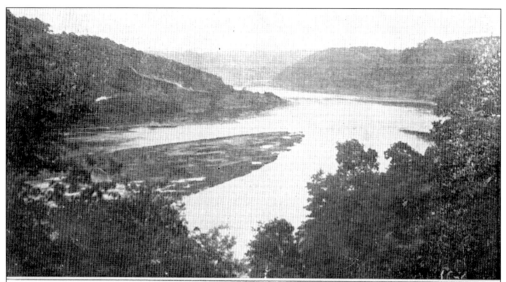

BEAUTIFUL ALLEGHENY PARKERS LANDING, PA

Babylon brothel keeper Ben Hogan resurfaced at Parker's Landing with his *Floating Palace*, a converted barge 140 feet long and 25 feet wide with 40 staterooms, a stage, and a large ballroom. Hogan anchored the Palace in the middle of the Allegheny River, on the line between Armstrong and Clarion counties, to avoid the law. In three illicit years at Parker's Landing, Hogan made $210,000. The *Floating Palace* sank after hitting a snag near Pittsburgh.

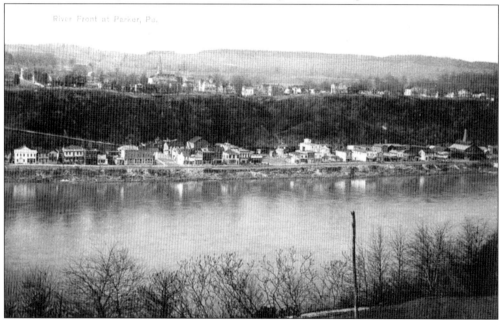

The Clarion Oil Company sank the first oil well at Parker, Armstrong County, in 1865. By 1870, Parker was an active oil center with a population of 7,000. By 1900, with a decline in oil production, the population had dropped to around 1,000. Parker has perhaps the most unique setting for a town on the Allegheny River: part of the city is on the river bank, the rest is on a bluff with a steep slope that drops to the river. An elevator carried people between bluff and flat.

REFERENCES

Barber, John W. and Henry Howe. *Historical Collections of the State of New York*. New York: S. Tuttle, 1841.

Commonwealth of Pennsylvania, Department of Health. *Report on the Sanitary Survey of the Allegheny River Basin*. Harrisburg, Pennsylvania: W. Stanley Ray, State Printer, 1915.

Cook, Anthony E. *The Cook Forest: An Island in Time*. Helena, Montana: Falcon Press, 1997.

Davis, A. J. *History of Clarion County Pennsylvania*. Syracuse, New York: D. Mason and Company Publishers, 1887.

Day, Sherman. *Historical Collections of the State of Pennsylvania*. Philadelphia: George W. Gorton, 1843.

Donehoo, George P. *A History of the Indian Villages and Place Names in Pennsylvania*. Lewisburg, Pennsylvania: Wennawoods Publishing, 1999 reprint of 1928 edition.

Egle, William H. *History of the Commonwealth of Pennsylvania*. Philadelphia: E. M. Gardner, 1883.

Emlenton Chamber of Commerce. *The Allegheny River: Its Islands, Eddies, Riffles and Winding Distances of Scenic Beauty*. Emlenton, Pennsylvania.

Fries, William J. and Lawrence W. Kilmer. *Iron Rails in Seneca Land*. New Port Richey, Florida: published by W. J. Fries.

Giddens, Paul H. *Pennsylvania Petroleum 1750-1872: A Document History*. Harrisburg, Pennsylvania: Pennsylvania Historical and Museum Commission, 1947.

Harpster, John W. (ed.). *Crossroads: Descriptions of Western Pennsylvania 1720-1829*. Pittsburgh, Pennsylvania: University of Pittsburgh Press, 1938.

Hoover, William N. *Kinzua: From Cornplanter to the Corps*. Lincoln, Nebraska: iUniverse, Inc., 2004.

Hufnagel, Hank. *Treasure Maps of Clarion County*. Clarion, Pennsylvania: Hufnagel Software, 2004.

McLaurin, John J. *Sketches in Crude Oil: Some Accidents and Incidents of the Petroleum Development in All Parts of the Globe*. Harrisburg, Pennsylvania: published by the author, 1898.

Merrill, Arch. *Southern Tier, Volume 1*. Rochester, New York: Seneca Book Binding Company.

Michener, Carolee K. *Oil, Oil, OIL!* Franklin, Pennsylvania: The Venango County Historical Society, 1997.

Ross, Philip W. *Allegheny Oil: The Historic Petroleum Industry on the Allegheny National Forest*. Warren, Pennsylvania: USDA Forest Service, Allegheny National Forest, 1996.

Schafer, Jim and Mike Sajna. *The Allegheny River: Watershed of the Nation*. University Park, Pennsylvania: The Pennsylvania State University Press, 1992.

Scheffer, George P. *True Tales of the Clarion River*. Clarion, Pennsylvania: Clarion County Historical Society, 2004 reprint of 1933 edition.

Schenk, J.S. *History of Warren County Pennsylvania*. Syracuse, New York: D. Mason and Company Publishers, 1887.

Swift, Robert B. *The Mid-Appalachian Frontier: A guide to Historic Sites of the French and Indian War*. Gettysburg, Pennsylvania: Thomas Publications, 2001.

University of the State of New York. *Vegetational Survey of Allegany State Park*. Albany, New York: New York State Museum Handbook 17, 1937.

Waddell, Louis M. and Bruce D. Bomberger. *The French and Indian War in Pennsylvania 1753-1763: Fortification and Struggle During the War for Empire*. Harrisburg, Pennsylvania: Pennsylvania Historical and Museum Commission, 1996.

Wainwright, Nicholas B. *The Irvine Story*. Philadelphia, Pennsylvania: Historical Society of Pennsylvania, 1964.

Wallace, Paul A.W. *Indian Paths of Pennsylvania*. Commonwealth of Pennsylvania, Harrisburg, Pennsylvania: Pennsylvania Historical and Museum Commission, 1998.

Wallace, Paul A.W. *Thirty Thousand Miles with John Heckewelder*. Lewisburg, Pennsylvania: Wennawoods Publishing, 1998.

Walsh, G. *Hemlock for the tanneries*. Garden and Forest, 9: 222-223. New York, New York: Garden and Forest Publishing, 1896.

Way, Frederick, Jr. *The Allegheny*. New York, New York: Farrar and Rinehart Inc., 1942.

Whitney, Gordon G. *From Coastal Wilderness to Fruited Plain*. New York, New York: Cambridge University Press, 1994.

Williams, Oliver P. *County Courthouses of Pennsylvania: A Guide*. Mechanicsburg, Pennsylvania: Stackpole Books, 2001.

Works Progress Administration. *Pennsylvania: A Guide to the Keystone State*. New York, New York: Oxford University Press, 1940.